QUICK & EASY
MOSAICS

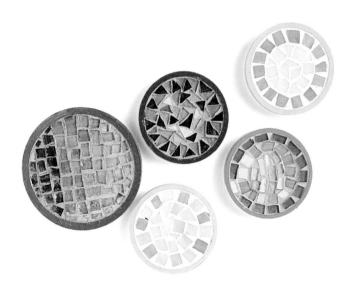

To Giappy

A particular thanks to Paola and Laura from the "La Catena di Vetro" shop in Milan, who furnished all the glass, pliers, and mounts necessary to prepare this book.

All glass is from the German company "Tiffany".
The paint is from APA of Bologna, Italy.
The company "Mark Service" of Milan.
The Mercanti Paint Supply Shop in Milan.
Marco Magheri of the Falegnameria MBS of Poggio a Caiano near Florence.
As usual I thank Cristina Brondi and also Chiara Pinto and Claudia Bini who created many of the pieces photographed here.
Raffaella Valentini for lending me things in the photography studio whether she wanted to or not.
Everone who allowed me to photograph their works: Donatella Zaccaria for the art mosaics, Maria Claudia Di Malta for the mosaics with transparent glass; Claudia Demartini and Fiorenza Novarese from Lu Monferrato's "Dreams & Design" Studio for the modern style boxes and tables; Mamma Ro's Workshop in Milan for the works done with marble for the "Venti" Collection; Penelopi 3 and Controbuffet both in Milan.

Library of Congress Cataloging-in-Publication Data Available

Photographs by Alberto Bertoldi and Mario Matteucci
Graphics and layout by Paola Masera and Amelia Verga
Translation by Sally Bloomfield

10 9 8 7 6 5 4 3

First paperback edition published in 1999 by
Sterling Publishing Company, Inc.
387 Park Avenue South, New York, N.Y. 10016
Originally published in Italy and © 1996 by R.C.S. Libri & Grandi Opere S.p.A., Milan
under the title *Decorare con il Mosaico*
English translation © 1998 by Sterling Publishing Co., Inc.
Distributed in Canada by Sterling Publishing
℅ Canadian Manda Group, One Atlantic Avenue, Suite 105
Toronto, Ontario, Canada M6K 3E7
Distributed in Great Britain and Europe by Cassell PLC
Wellington House, 125 Strand, London WC2R 0BB, England
Distributed in Australia by Capricorn Link (Australia) Pty Ltd.
P.O. Box 6651, Baulkham Hills, Business Centre, NSW 2153, Australia
Printed in China

Sterling ISBN 0-8069-3895-1 Trade
 0-8069-4475-7 Paper

QUICK & EASY
MOSAICS

Innovative Projects & Techniques

MARIARITA MACCHIAVELLI

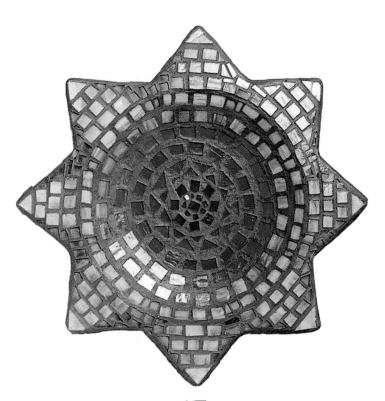

STERLING PUBLISHING CO., INC.
NEW YORK

CONTENTS

INTRODUCTION

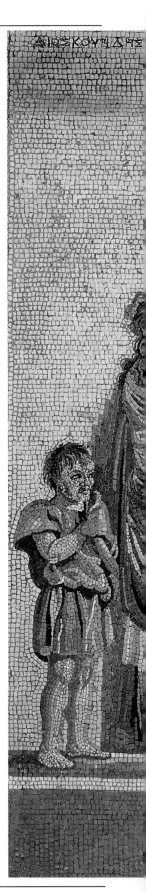

Of all the decorative arts, glass mosaic is without a doubt one of the most fascinating. Mosaic designs, with their ability to catch and reflect light, can enrich even the simplest of objects with a brightness that makes them seem special.

This book is an easy-to-understand manual about the art and techniques of mosaic work for master and novice alike. I hope it will be an ongoing source of ideas and inspiration for creating beautiful mosaics of your own.

Glass mosaic can be done on almost any surface -without the use of a chisel or clamps, and without grids or stays to break the glass- by gluing pieces of cut glass in place and adding cement to fill in the gaps. It is a decorative technique that anyone who has a sense of design, the willingness to do a bit of handwork, and some patience can use to create a masterpiece. The versatility and creativity of glass mosaic are its most appealing qualities.

Creating traditional mosaics is another technique altogether. It begins with developing a paper painting or drawing -sometimes very large and complex- which is then translated into a mosaic on a wall or floor. Detailed planning is fundamental to the successful interpretation of a traditional mosaic design.

The organization of this book is very straightforward. The first half begins with the Technical Guide, which describes the tools and materials used in mosaic work, followed by step-by-step directions and photographs for six different projects.

The second half of the book is designed to stimulate your creativity. In it you will find ideas for mosaic designs and projects grouped by category (boxes, tables, frames, small projects, and jewelry), a section about clear glass and marble, some artistic works of mosaic art, and a collection of patterns that you can photocopy and use in your own projects.

MARIARITA MACCHIAVELLI

This charming theater scene of traveling minstrels (200–100 B.C.) decorated a city wall in Pompeii. Today it is displayed in the National Archaeological Museum of Naples.

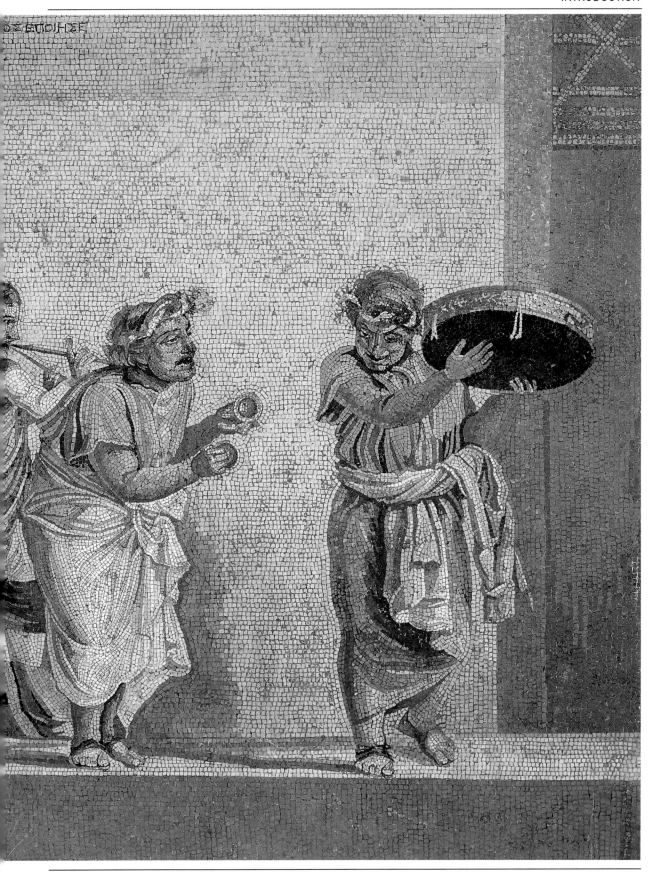

HISTORICAL BACKGROUND

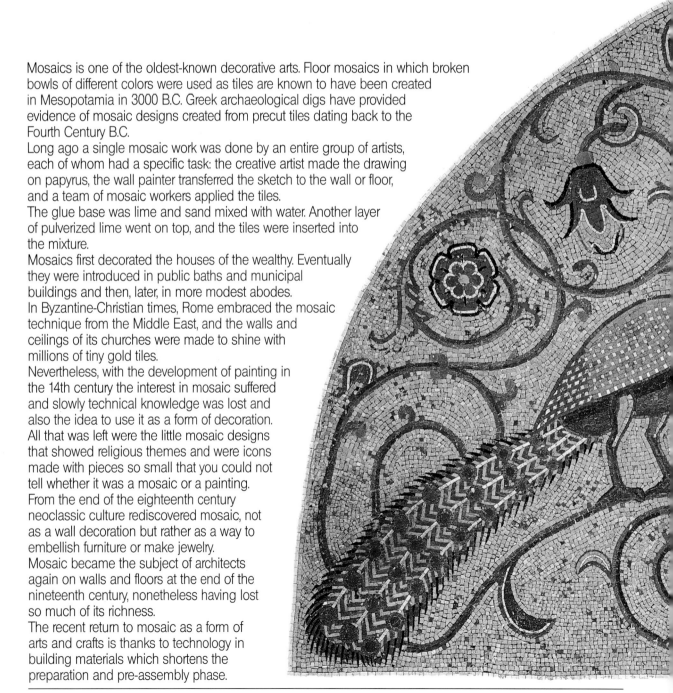

Mosaics is one of the oldest-known decorative arts. Floor mosaics in which broken bowls of different colors were used as tiles are known to have been created in Mesopotamia in 3000 B.C. Greek archaeological digs have provided evidence of mosaic designs created from precut tiles dating back to the Fourth Century B.C.

Long ago a single mosaic work was done by an entire group of artists, each of whom had a specific task: the creative artist made the drawing on papyrus, the wall painter transferred the sketch to the wall or floor, and a team of mosaic workers applied the tiles.

The glue base was lime and sand mixed with water. Another layer of pulverized lime went on top, and the tiles were inserted into the mixture.

Mosaics first decorated the houses of the wealthy. Eventually they were introduced in public baths and municipal buildings and then, later, in more modest abodes.

In Byzantine-Christian times, Rome embraced the mosaic technique from the Middle East, and the walls and ceilings of its churches were made to shine with millions of tiny gold tiles.

Nevertheless, with the development of painting in the 14th century the interest in mosaic suffered and slowly technical knowledge was lost and also the idea to use it as a form of decoration. All that was left were the little mosaic designs that showed religious themes and were icons made with pieces so small that you could not tell whether it was a mosaic or a painting.

From the end of the eighteenth century neoclassic culture rediscovered mosaic, not as a wall decoration but rather as a way to embellish furniture or make jewelry.

Mosaic became the subject of architects again on walls and floors at the end of the nineteenth century, nonetheless having lost so much of its richness.

The recent return to mosaic as a form of arts and crafts is thanks to technology in building materials which shortens the preparation and pre-assembly phase.

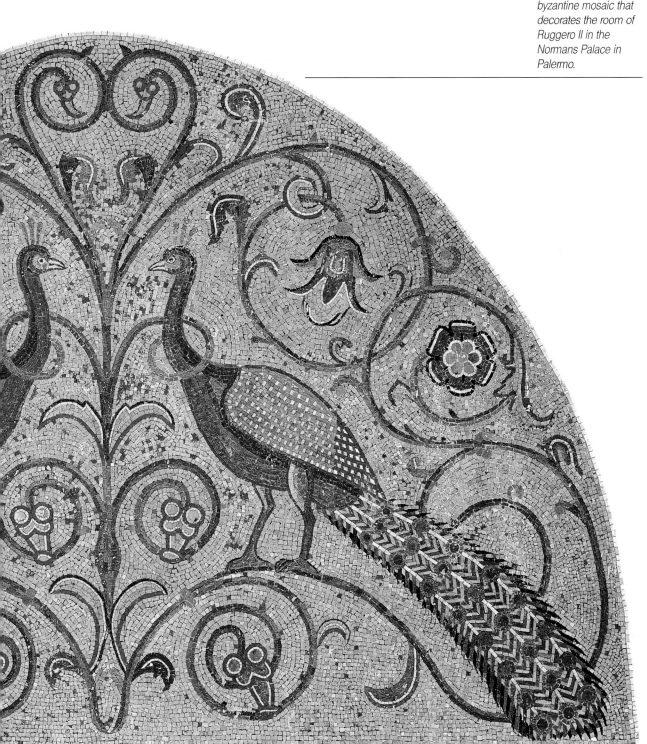

These two precious peacocks are part of a byzantine mosaic that decorates the room of Ruggero II in the Normans Palace in Palermo.

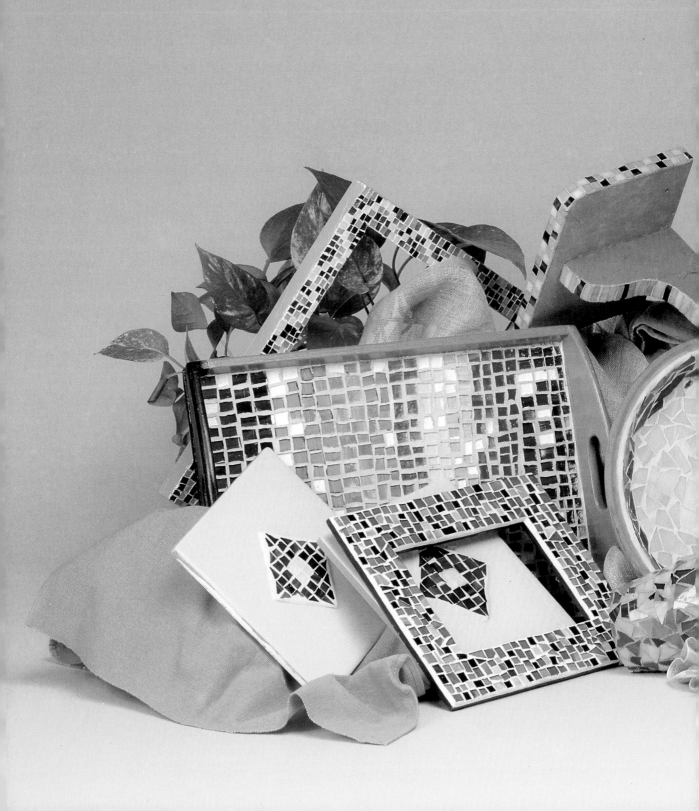

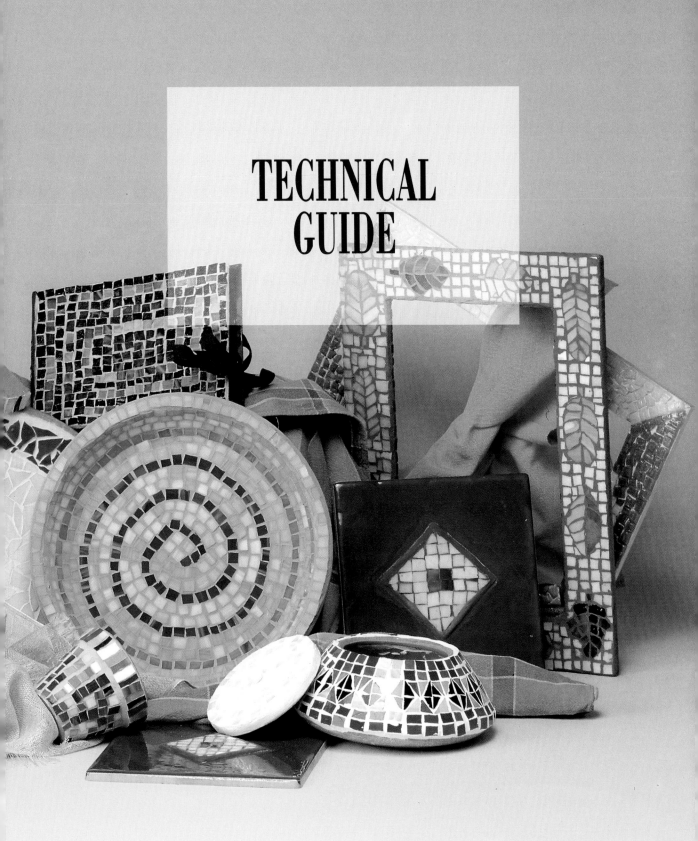

TECHNICAL
GUIDE

GLASS MOSAIC

How do you create a mosaic?

If you use glass –or a glasslike material, such as tiles or plates that are not too thick– the technique is relatively simple:

(1) You plan your project.

(2) You use the appropriate glue to apply precut bits of glass to the surface you want to decorate, forming a design or arranging the glass bits in a random manner, leaving a small gap between pieces.

(3) After all the pieces have been glued securely in place, you fill in the gaps completely with cement.

(4) After the cement is dry, you clean off the surface, making sure all the gaps remain well filled.

I don't spend much time planning my projects, but some planning is necessary for any successful mosaic design or technique. Begin with the practical aspects of mosaic work. Learn how to glue and cement with randomly placed glass bits first. Practice until you feel confident. When you have decided on your project, draw and color the design on paper before beginning the actual work.

Testing and practicing are vitally important. Don't try any project design or technique that you haven't thoroughly tested and practiced first. If you come up with an idea for a project and throw yourself into it without planning, you could run into all sorts of unanticipated problems as you work.

Experiment to find the right thickness and consistency of cement for various uses. Before permanently gluing glass bits in place, move them around on the surface to find the right positions.

Don't be discouraged if some aspects of mosaic work seem difficult at first.

Be patient, be methodical, and be persistent. Creating mosaics can be a very relaxing way to spend your time.

EQUIPMENT AND MATERIALS

THE GLASS

The glass used in mosaic work is usually opaque and milky in appearance.

The transparent colored glass used in stained glass projects doesn't work as well in mosaics as the opaque type, because any imperfections in the glue or on the surface that has been decorated will show through. Used correctly, however, and with the right glue, transparent colored glass can lend itself to interesting and creative projects.

Opaque glass is usually streaked like marble. It has a front and a back, which are easily distinguished. The front has more streaks and variations in color than the back, which is more uniform in color and texture. You can use either the front or back of the glass as the side that shows on your projects, depending on the look you want to create. Mosaic glass is chalky, and it can be easily cut or broken. You can find mosaic glass in crafts and hobby shops in 1 inch x 24 inch (0.6 cm x 0.6 m) strips and in both square and rectangular sheets.

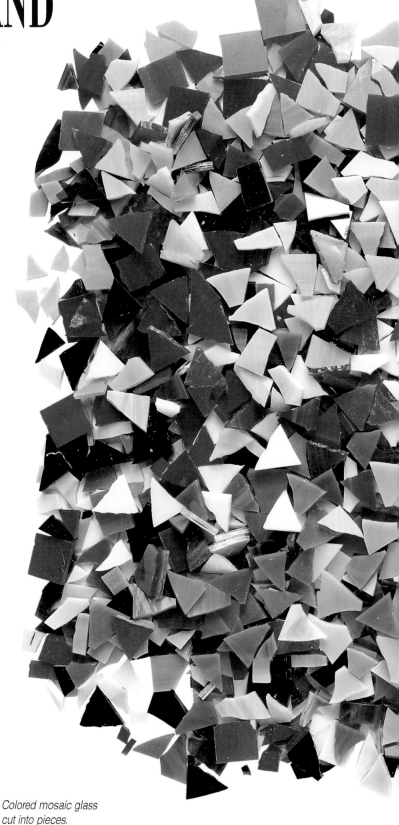

Colored mosaic glass cut into pieces.

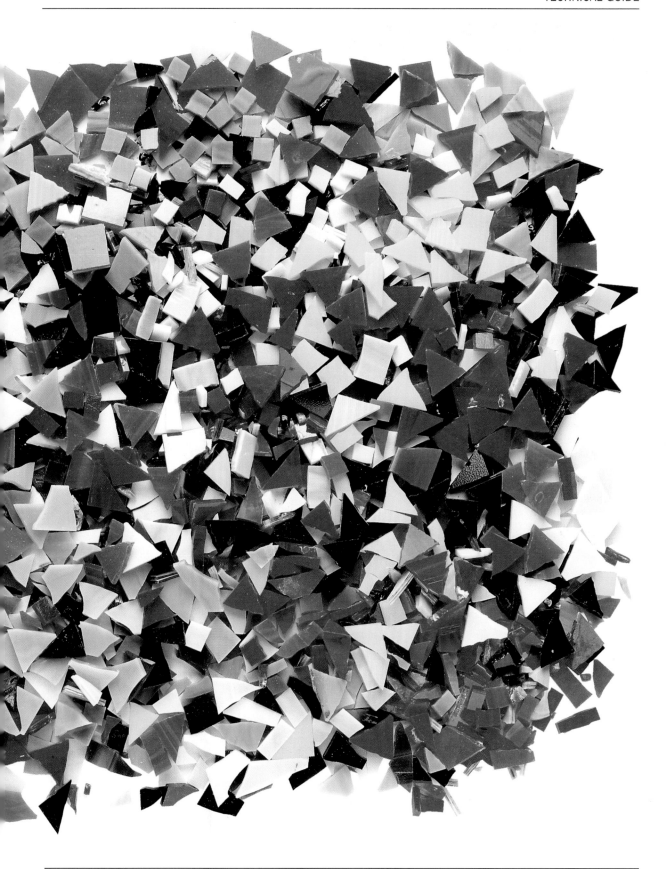

Here are some of the available colors and shades of opaque opalescent glass. There are three narrow strips of each sample. The first group contains warm greens, yellows, and browns. The middle group features soft beiges and apricots, intense reds and purples, and cold whites. The last group contains sky, turquoise, and ocean blues.

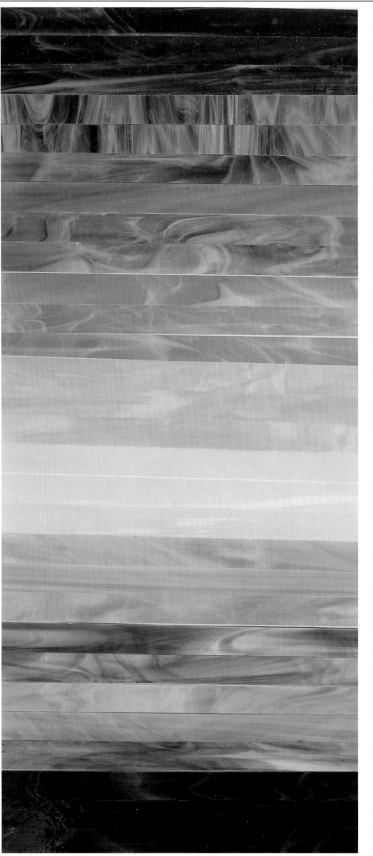

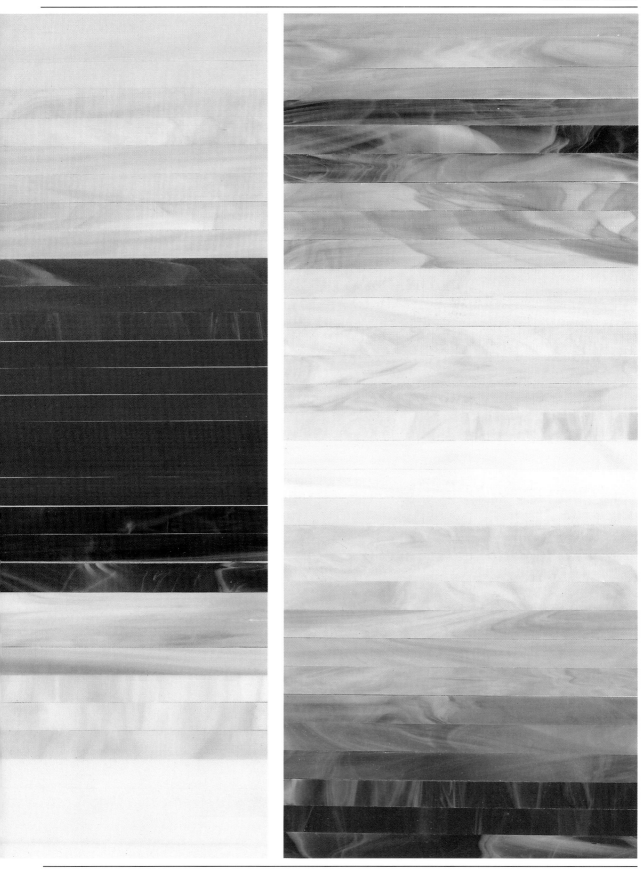

PRECUT GLASS

You can find precut glass squares for mosaic work in crafts and hobby shops. The fairly regular little squares shown here are ideal for creating a mosaic from a pattern.

It is easier to use purchased precut glass squares than to cut them yourself, but when grouped into designs they appear flat and uniform.

PAINTED CLEAR GLASS

Clear glass is very different from opaque glass, and it can be an economical substitute. If you color clear glass with glass paint, be sure to place the pieces in your project with the painted side down. Also note that clear glass is less fragile than the opaque type, but it is also more difficult to cut.

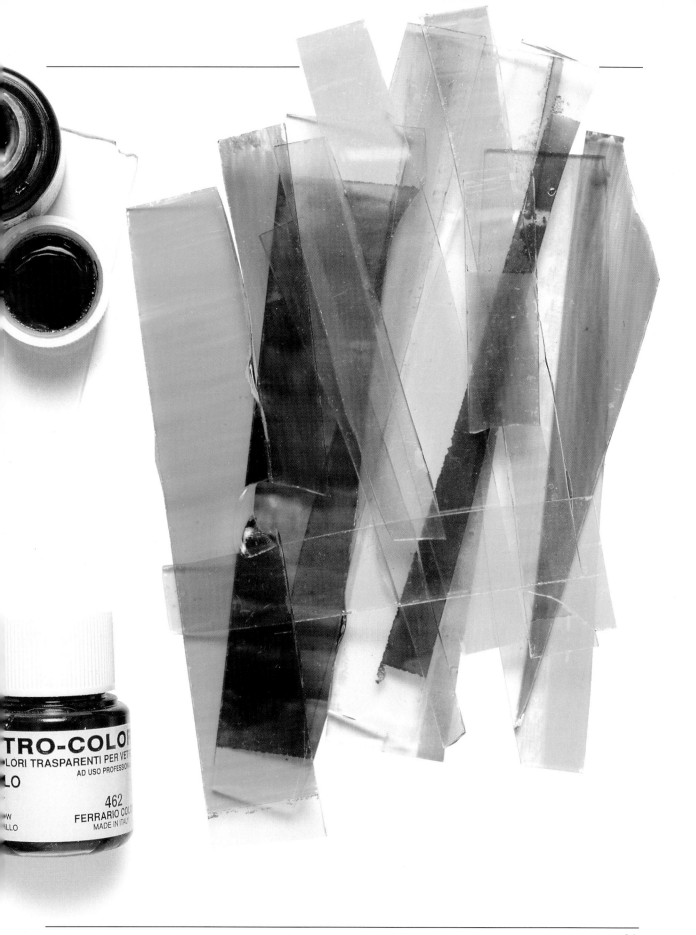

BROKEN PLATES

Using broken plates as mosaic pieces can be the most economical way to create a project. You break up the plates and then arrange and glue the pieces to the project surface. It can be challenging to get some curved pieces to stick to some surfaces. You generally use a heavy tile glue or regular powdered cement.

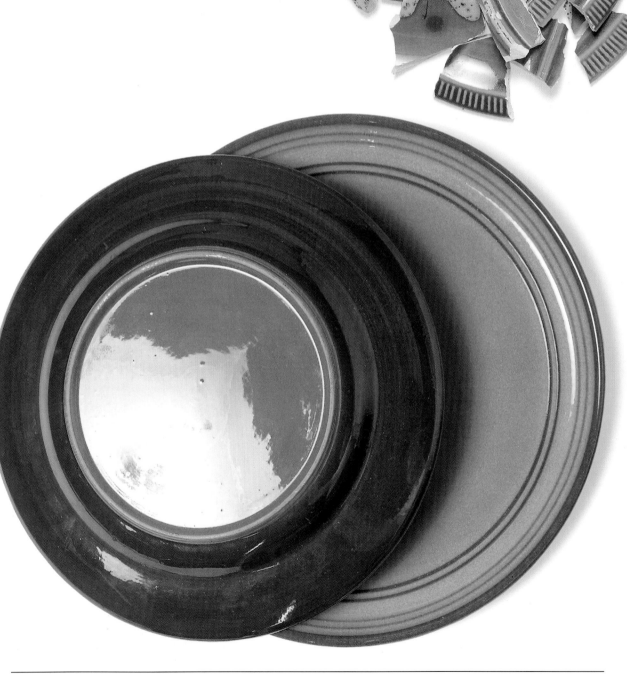

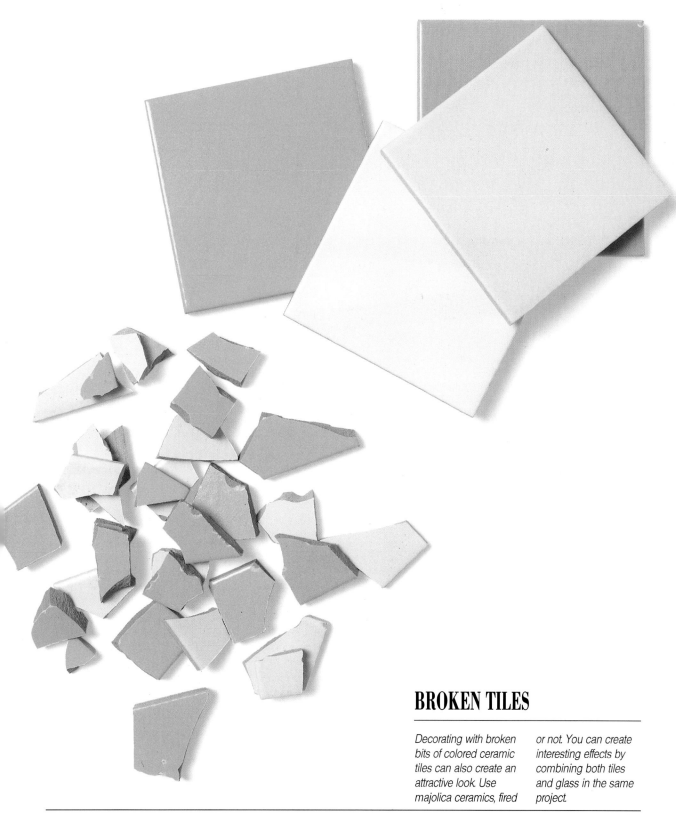

BROKEN TILES

Decorating with broken bits of colored ceramic tiles can also create an attractive look. Use majolica ceramics, fired or not. You can create interesting effects by combining both tiles and glass in the same project.

GLASS AND TILE CUTTERS

Cutting is a fundamental part of the mosaic process. Below is an overview of the most useful tools for this task. Be sure to always wear safety glasses when cutting glass.

MOSAIC PLIERS - This tool has two sharp metal disks that break the glass. Carefully place a glass strip between the disks at a 90-degree angle and squeeze the handles. These pliers have a small pouch to catch the flying bits of glass as you cut.

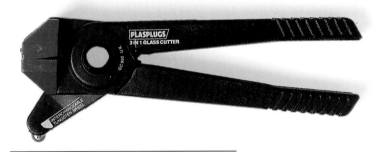

WHEEL GLASS CUTTER - Use this tool to make straight cuts by running the sharp wheel over the surface of the glass. Use a ruler for straight cuts. Make your incision and place the top part of the jaw on the upper side of the glass. Squeeze the jaw to make pressure from underneath. The glass will break perfectly on the pre-cut line.

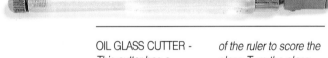

OIL GLASS CUTTER - This cutter has a reservoir that you fill with oil to lubricate the rolling head of the cutter. It is the only tool that makes perfect cuts with a beveled edge. To use the oil glass cutter, place a metal ruler on top of the glass and forcefully scrape the rolling head of the cutter along the edge of the ruler to score the glass. Turn the glass over and hit it along the scored line with the end of the tool. The glass should break perfectly along the line that you have scored (alternatively, you can break the glass on the edge of a table, but be sure to wear gloves to prevent cutting yourself).

TILE CUTTER - This tool works on the same principle as the wheel glass cutter, but it has a bigger and sharper wheel. Use it to make straight cuts.

ENGRAVER - Use this tool to make deep cuts in glass and tiles.

VARIOUS TYPES OF CUTS

Here are six different ways of cutting glass shapes.

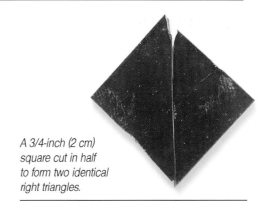

A 3/4-inch (2 cm) square cut in half to form two identical right triangles.

A leaf shape cut with the wheel glass cutter.

Several 1/2-inch (1.25 cm) squares.

These 3/4-inch (2 cm) squares can be cut with the oil glass cutter or the wheel cutter.

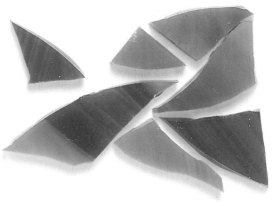

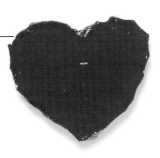

A heart shape cut from a square piece of glass with the oil glass cutter and then shaped with the mosaic pliers.

Irregularly shaped glass broken with the mosaic pliers.

SPATULAS

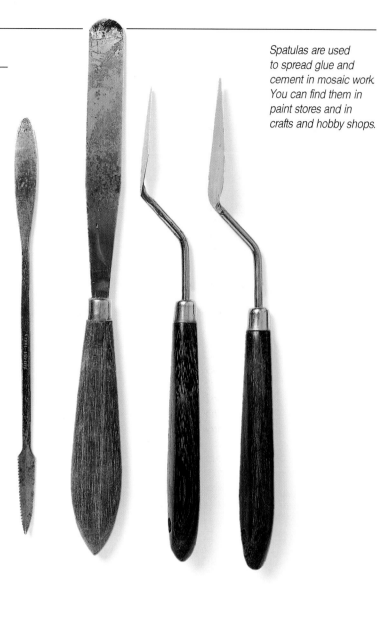

Spatulas are used to spread glue and cement in mosaic work. You can find them in paint stores and in crafts and hobby shops.

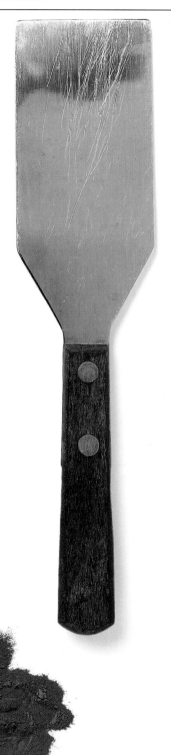

CEMENTS

Another important process in the technique of mosaic work is filling in the gaps, and for this you usually use cement or caulk. Mix up cement from powder on an as-needed basis. Don't use purchased premixed cement, which can crack after it dries. The amount of cement you need at one time depends on the surface

you want to decorate. WHITE CEMENT - You can find white cement in paint and hardware stores. It is a white powder that mixes with water and dries quickly. After 24 hours it cannot be removed. When you mix it, add enough water to the powder so that the cement is runny in consistency, or add more powder to make a paste that you

can spread with your hands. Do some experimenting to find the right mix. There are two methods of coloring cement: (1) Add colored paint powder to white cement powder, or (2) add purchased premixed ready-to-use acrylic paint. Acrylics have intense tones that create bright colors of cement.

GLUES

Using the right glue is very important in mosaic work. The wrong glue can ruin a project that has taken you days to create.

TILE GLUE - This special glue is an elastic and coarse paste. It is good for use on large areas or vertical surfaces, but not with clear glass bits, because you can see it through the glass. In order for tile glue to adhere, you must apply it in a 1/8-inch (3 mm) thickness. Before spreading the paste, you must wait until it holds in place well, even if it sticks immediately. Tile glue works well on terra-cotta, wood, and plastic, but it takes a long time to dry thoroughly.

CLEAR LIQUID GLUE FOR GLASS MOSAIC - You can find this type of glue in crafts and hobby shops. It takes a long time to dry and allows you only 10-15 minutes to finalize the position of your pieces before it sets. It should be used only on flat, horizontal surfaces. Don't use it on flowerpots, for instance, with their vertical and rounded sides, because the pieces are likely to slip and move. Apply the glue using a brush with rigid bristles.

CLEAR STRONG GLUES - These glues can be found in hardware stores as well as in crafts and hobby shops. The first is a well-sticking epoxy that comes as two separate components, which you mix together in a 1:1 ratio. It dries in less than a minute, so you need to mix small amounts frequently as you place the glass bits. The second glue is a silicone adhesive, which is sold as a sealer for wall cracks.

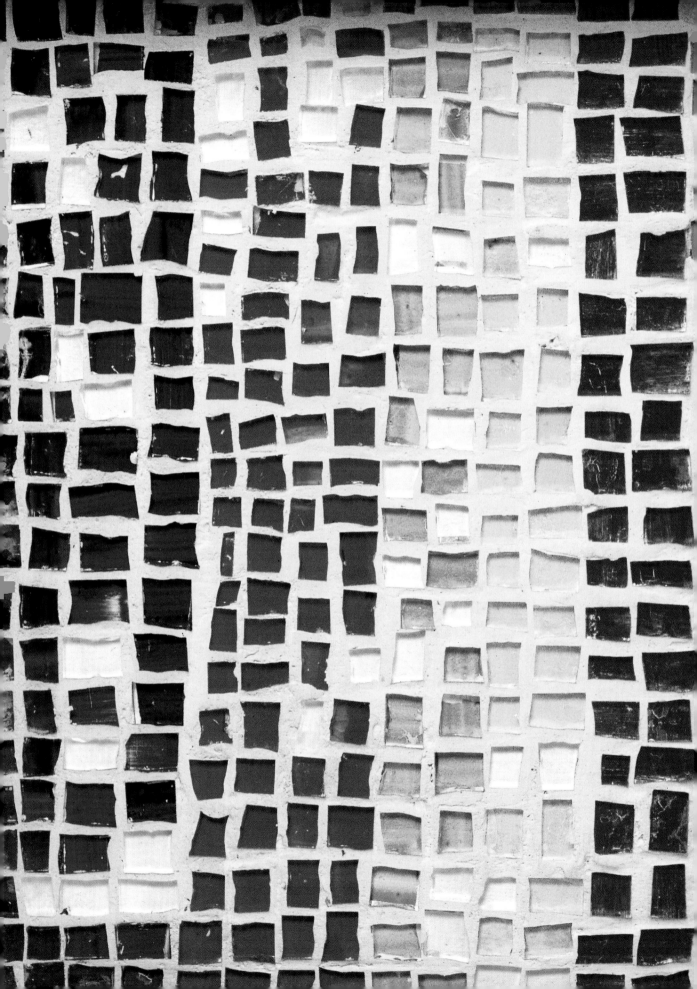

PROJECTS

TERRA-COTTA BOWL

NECESSARY MATERIALS

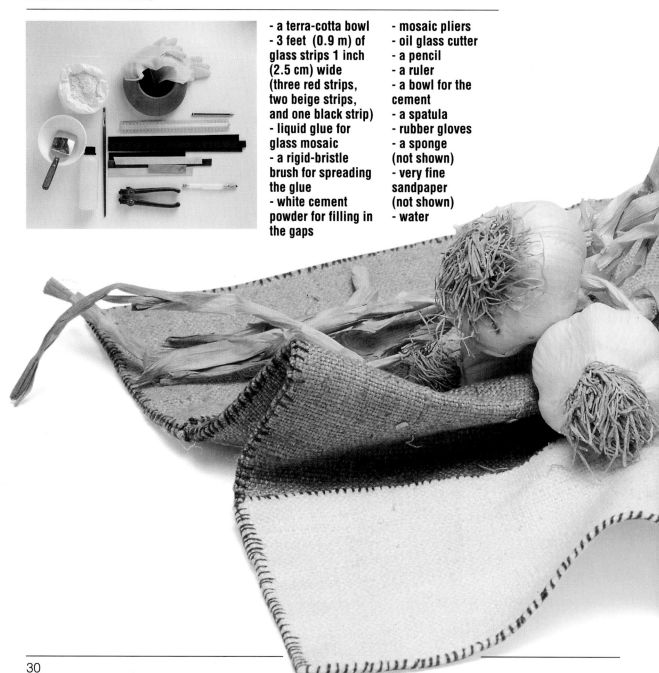

- a terra-cotta bowl
- 3 feet (0.9 m) of glass strips 1 inch (2.5 cm) wide (three red strips, two beige strips, and one black strip)
- liquid glue for glass mosaic
- a rigid-bristle brush for spreading the glue
- white cement powder for filling in the gaps
- mosaic pliers
- oil glass cutter
- a pencil
- a ruler
- a bowl for the cement
- a spatula
- rubber gloves
- a sponge (not shown)
- very fine sandpaper (not shown)
- water

This terra-cotta bowl was once a water bowl for ducks. You can find similar bowls at a plant nursery or florist shop. You can also use regular terra-cotta planters and get equally good results. I prefer using warm colors in my designs, but you can use any color or combination of colors that you like.

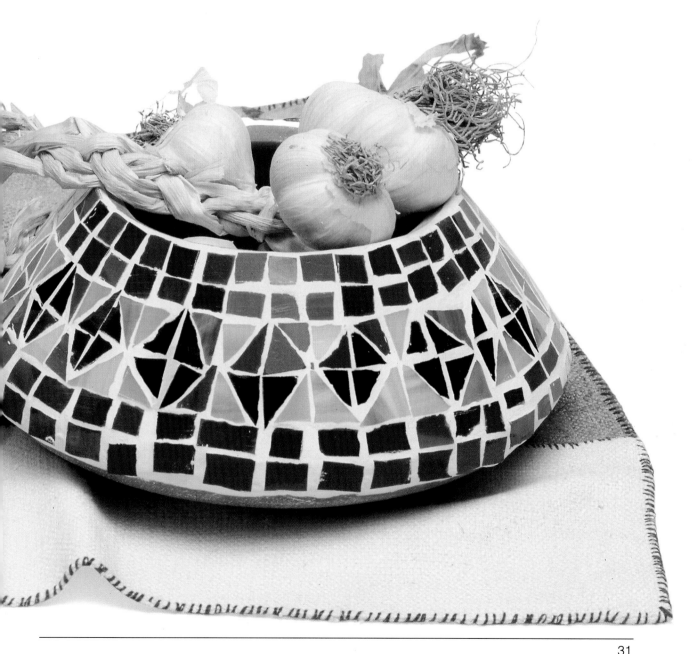

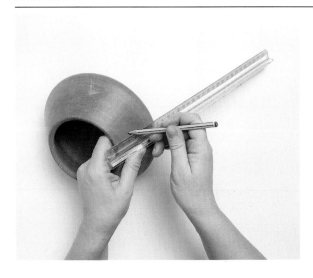

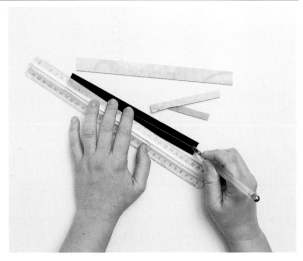

1 If you are using a pattern or have a specific design in mind, mark it on the sides of your bowl with a pencil. Use a ruler to mark straight lines.

2 Use the oil glass cutter to score straight lines in the glass. (You can use a regular glass cutter instead, but be sure to apply a lot of pressure if you do.) Turn the glass over and hit it on the scored line or use the mosaic pliers' handles; the glass will break along the line.

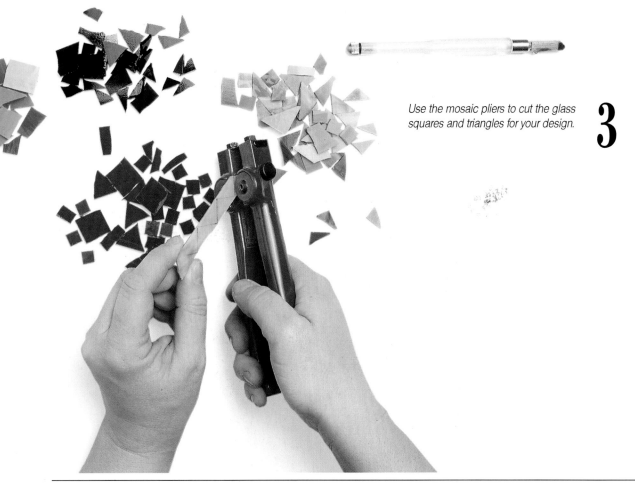

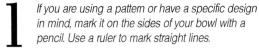

Use the mosaic pliers to cut the glass squares and triangles for your design.

3

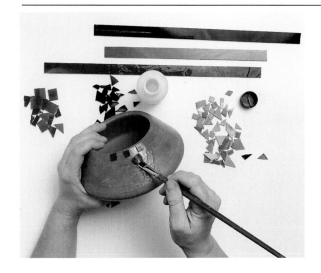

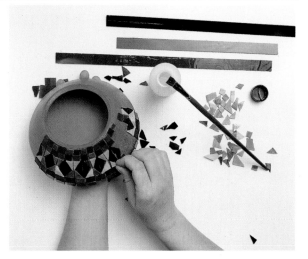

4 After all of your glass pieces are cut, spread the mosaic glue on the outside of your bowl; the clear liquid will allow any design lines to show through. Let the glue dry for a minute or two before placing any glass bits in it. The waiting time may vary according to your local temperature and humidity. You can easily tell if the glue is not ready: if the glass pieces slip, the glue is still too wet. If the glass will not stick in place, the glue is too dry.

5 Attach all of the glass bits that make up your design, and then prepare the cement that will be used to fill in the gaps between the glass bits: pour some cement powder into a bowl and add water little by little until the mixture has a soft, pasty consistency.

6 Spread the cement with a spatula, a little at a time, to areas of about 4–5 inches (10–15 cm), making sure to completely fill in all the nooks and crannies.

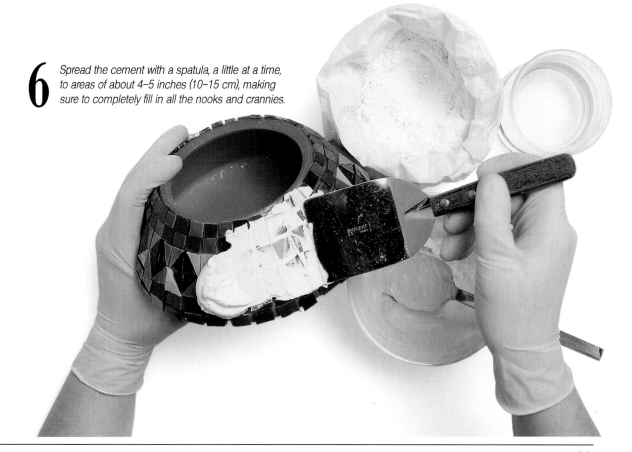

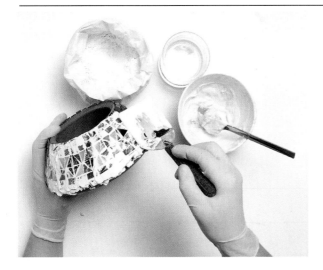

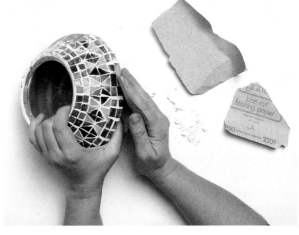

7 Cover the entire mosaic design with the cement. Don't worry about any cement that still remains on the surface of the glass.

8 Let the cement dry for about 30 minutes (again depending on temperature and humidity) and then remove the excess cement with very fine sandpaper.

9 When you are sure that the cement is really dry, remove any remaining excess with a moist sponge (not too wet); then polish the glass with a clean dry cloth. (Tip: don't let the cement dry in a thick layer on top of the glass, because once dry it is very difficult to remove. The timing of the cement stage is very important.)

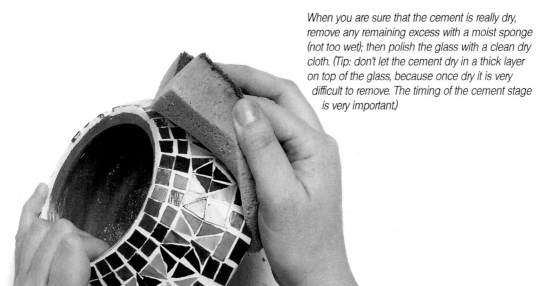

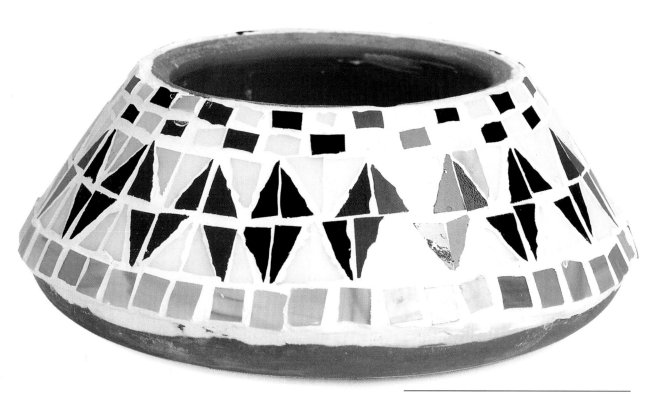

The finished bowl is shown below. Above it is a bowl with a similar design but different colors.

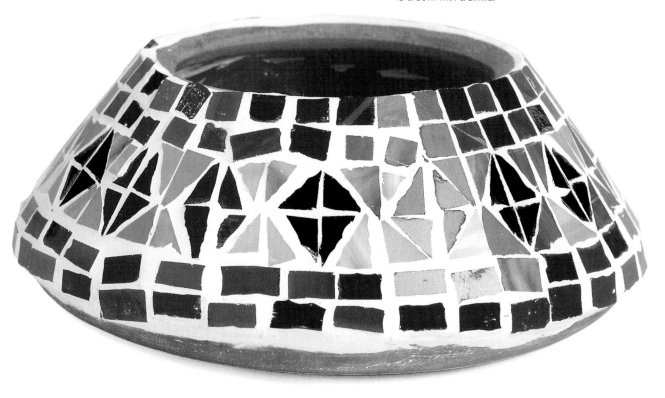

LEAF FRAME

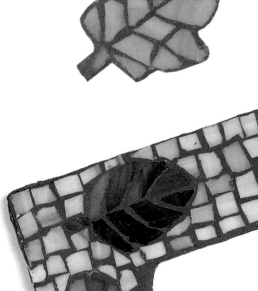

Mosaic frames are special, and when they frame a mirror they become beautiful decorations. Just remember, the surface on which you apply your mosaic design must be a flat one. You can buy frames or use those you have around the house. You can also make frames from precut kits or glue together strips of wood from a lumberyard. Wood frames are the most suitable type for mosaics.

I used tile glue on this frame. Liquid glue would have been absorbed by the porous wood, and two-component epoxy glue would have dried too quickly for covering such a large area. The hardest part of this project was cutting the leaf shapes with the mosaic pliers. The design is enhanced by precolored cement.

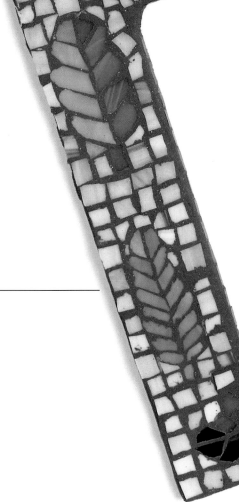

NECESSARY MATERIALS

- an unfinished wood frame
- 3 feet (0.9 m) of glass strips 1 inch (2.5 cm) wide in various greens and beiges
- tile glue
- terra-cotta–colored acrylic paint
- cement powder
- mosaic pliers
- oil glass cutter
- a spatula

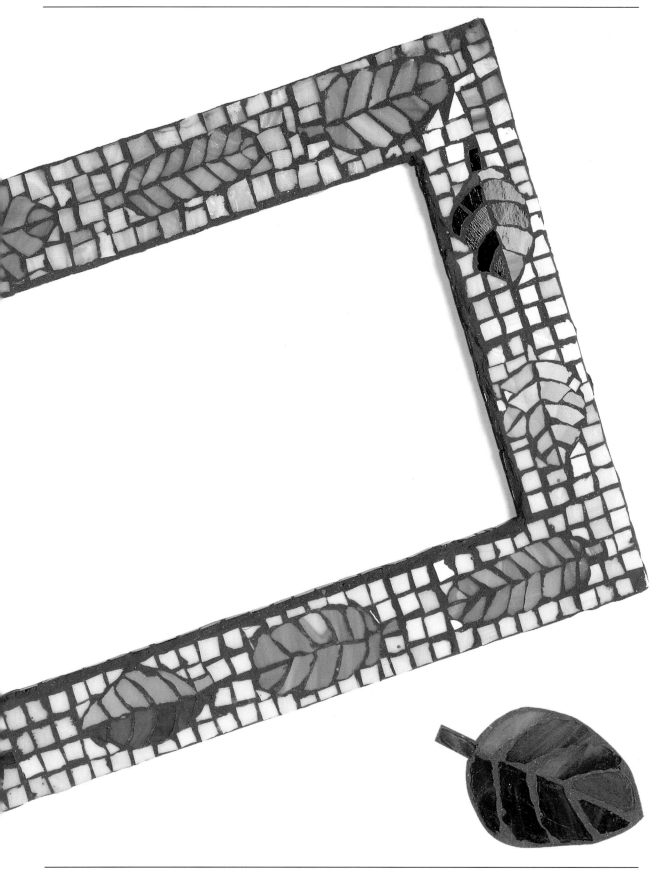

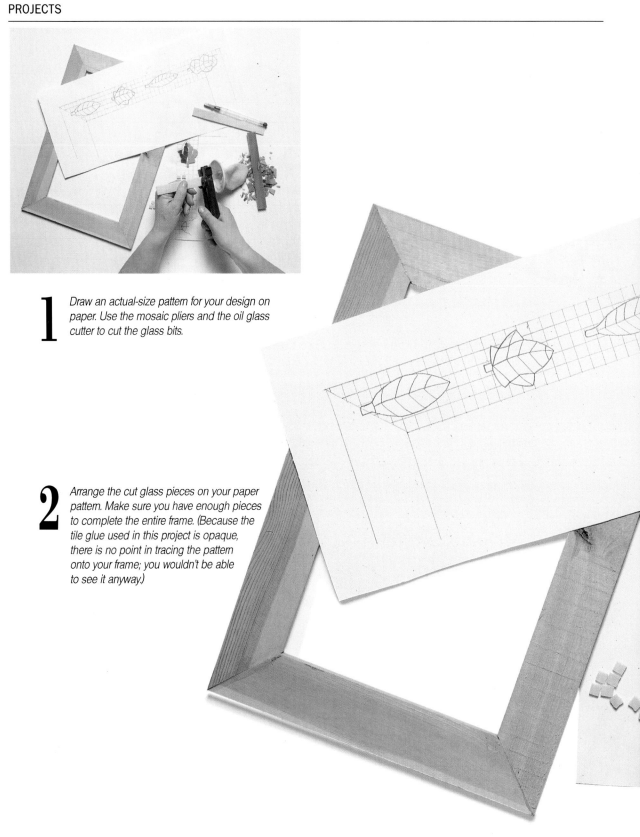

1 Draw an actual-size pattern for your design on paper. Use the mosaic pliers and the oil glass cutter to cut the glass bits.

2 Arrange the cut glass pieces on your paper pattern. Make sure you have enough pieces to complete the entire frame. (Because the tile glue used in this project is opaque, there is no point in tracing the pattern onto your frame; you wouldn't be able to see it anyway.)

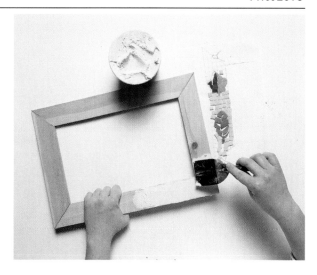

Use a spatula to spread the tile glue on the frame as smoothly as possible to a thickness of at least 1/8 inch (3 mm).

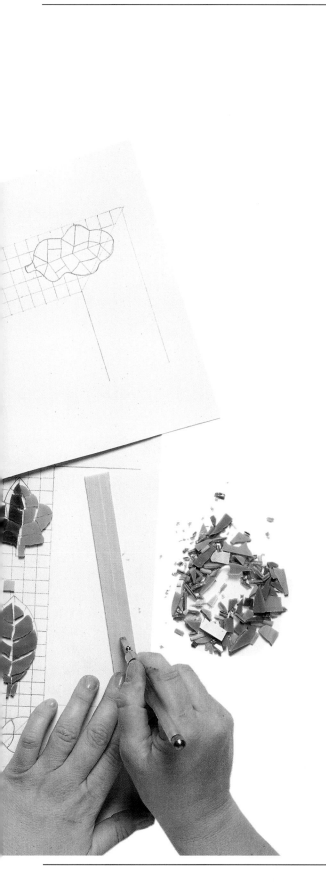

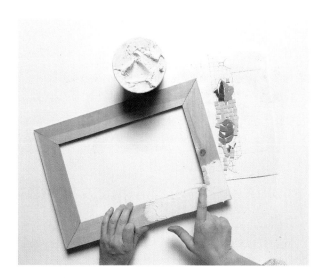

Arrange the glass bits on the frame by following your paper pattern.

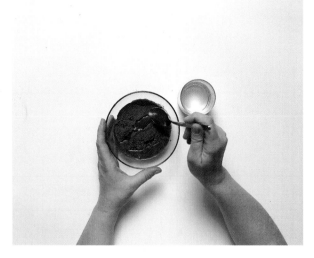

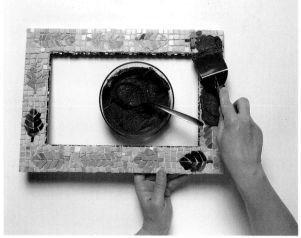

5 *In a bowl prepare the terra-cotta–colored cement. Slowly add water until the mixture is a smooth paste without any lumps.*

Spread the colored cement with a spatula, making sure to completely fill in all the gaps. **6**

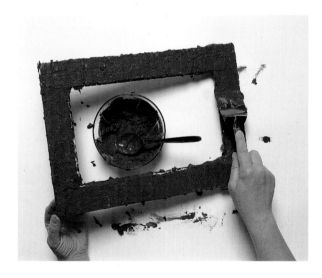

7 *Cover the entire surface of the frame with the cement.*

8 Wait about 30 minutes, and then remove the excess cement with a moist sponge.

9 Let the cement dry a little more, and then polish the surface with a clean, dry cloth.

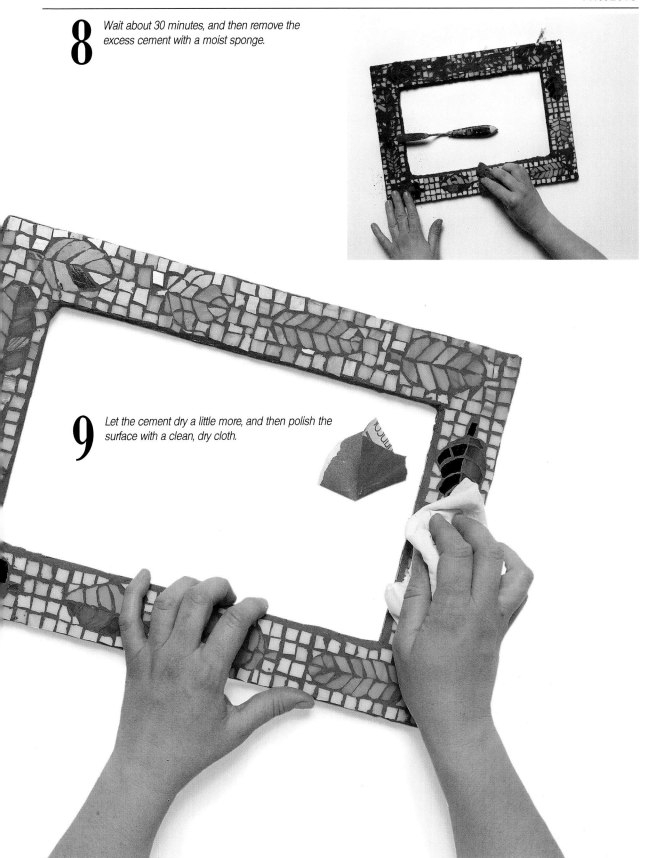

TERRA-COTTA FLOWERPOT HOLDER

Here is another decorated terra-cotta surface. It is a shallow bowl, the type that you might put under a flowerpot. I glued on the broken glass bits at random and finished the piece with an intense yellow cement that I colored.

NECESSARY MATERIALS

- a shallow terra-cotta bowl
- colored glass in light yellow, deep yellow, and red
- mosaic pliers
- tile glue
- white cement powder
- yellow acrylic paint
- a spatula

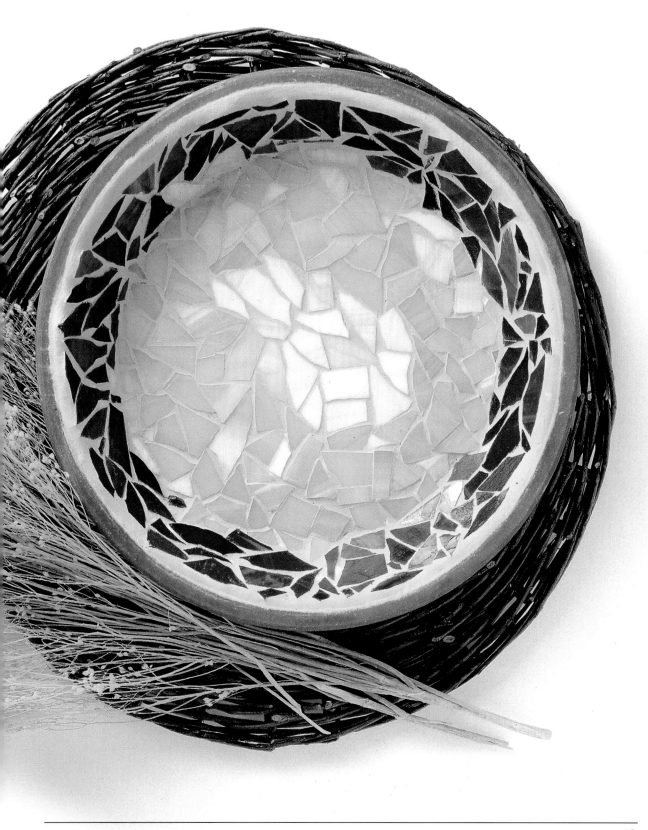

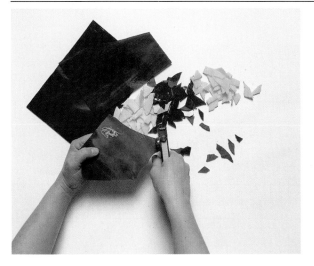

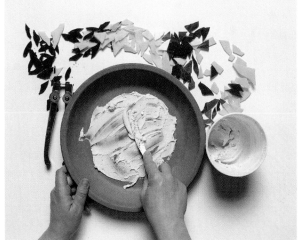

1 Use the mosaic pliers to break the glass into irregular pieces that are all about the same size.

Use a spatula to spread the tile glue evenly on the bowl, making a layer of about 1/8 inch (3 mm) thick. **2**

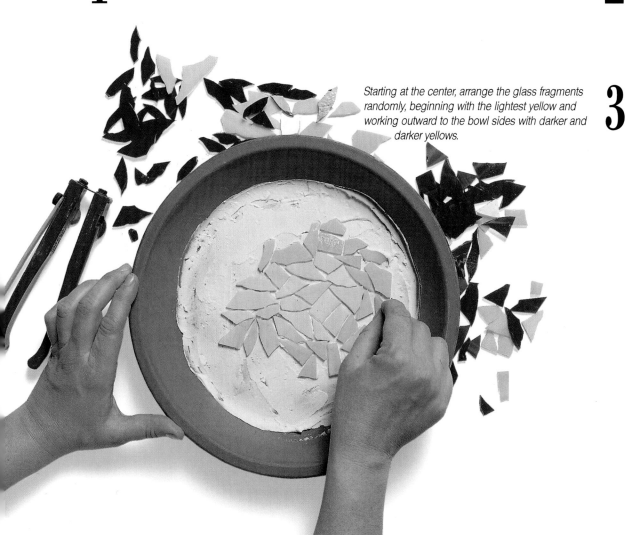

Starting at the center, arrange the glass fragments randomly, beginning with the lightest yellow and working outward to the bowl sides with darker and darker yellows. **3**

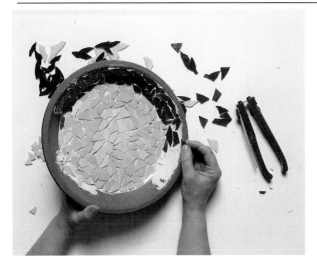

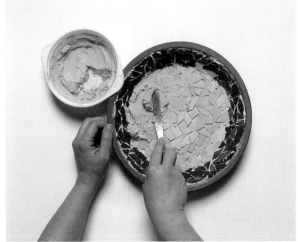

4 After covering the bottom of the bowl with yellow bits, cover the sides with red bits. Make sure the gaps between the irregularly shaped pieces remain small.

5 Prepare the white cement in a bowl and then add acrylic paint. Slowly add water and stir the mix until it becomes a brilliantly colored soft paste. (You can also use pigment powder to color the cement but the colors will be much less bright and more complicated to prepare.) Use a spatula to spread the cement on the bowl, making sure to completely fill in all the gaps.

6 Let the cement dry for 15 minutes (if you have colored the cement with acrylic paint then your drying time will be less) and then clean the excess with a moist cloth. Let it dry a little while longer and then polish it with a clean soft cloth.

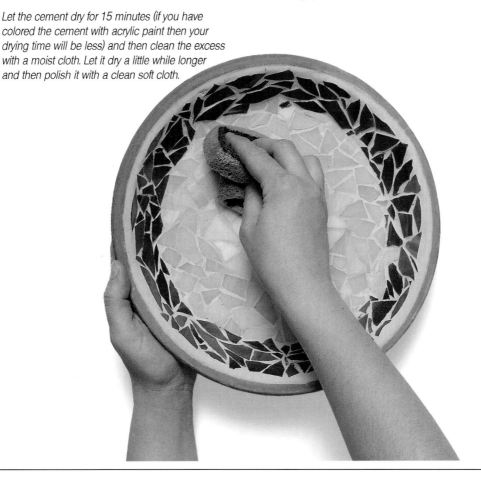

SWITCHPLATE

Are you looking for a small project? Personalize a switchplate! Make it match your decor, or let it be whimsical. This design evolved as the placing of the glass bits proceeded; there was no pattern for it. I used the two-component epoxy glue because of its strength and the fact that the surface to be decorated was small enough to be suitable for this type of glue.

NECESSARY MATERIALS:

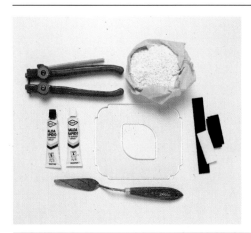

- a switchplate
- black and pale gray strips of glass
- mosaic pliers
- two-component epoxy glue
- white cement powder
- a spatula

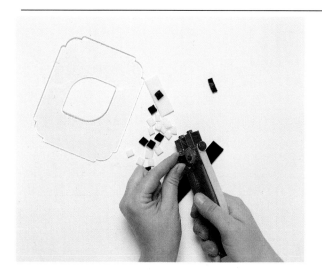

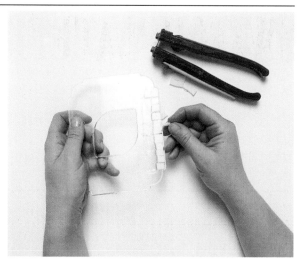

1 Use the mosaic pliers to cut irregular glass shapes that are all about the same size.

2 Prepare the two-component epoxy glue following the manufacturer's directions. Use a spatula to spread the glue, and then immediately position the glass bits. (You must work quickly or else re-spread the glue, because it dries in 2–3 minutes.)

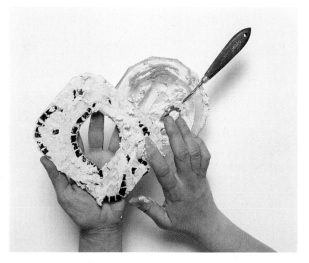

4 Let the finished piece dry for about an hour, and then clean off the excess cement with a moist sponge. Let it dry more, and then use very fine sandpaper to remove the remainder of the excess. Finish by polishing with a clean, dry cloth.

3 In a bowl mix 2–3 tablespoons of cement powder and a little water to make a paste. Use your hands to spread the cement on the switchplate, making sure to completely fill in all the gaps.

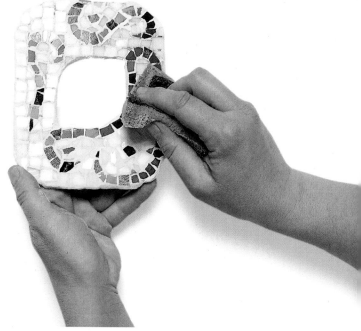

PARTY FAVOR FRAME

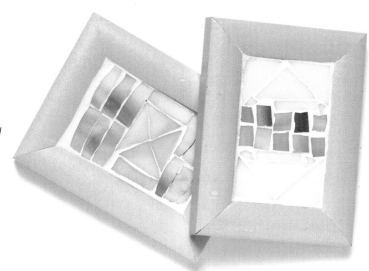

When I saw these little frames, I immediately thought of making mosaic projects, which is especially easy to do in a sunken area bounded by a lip or wall. For this project I used pastel colors and white cement.

NECESSARY MATERIALS

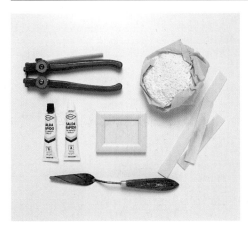

- a small white wood frame
- pink and white strips of glass
- mosaic pliers
- two-component epoxy glue
- white cement powder
- a spatula

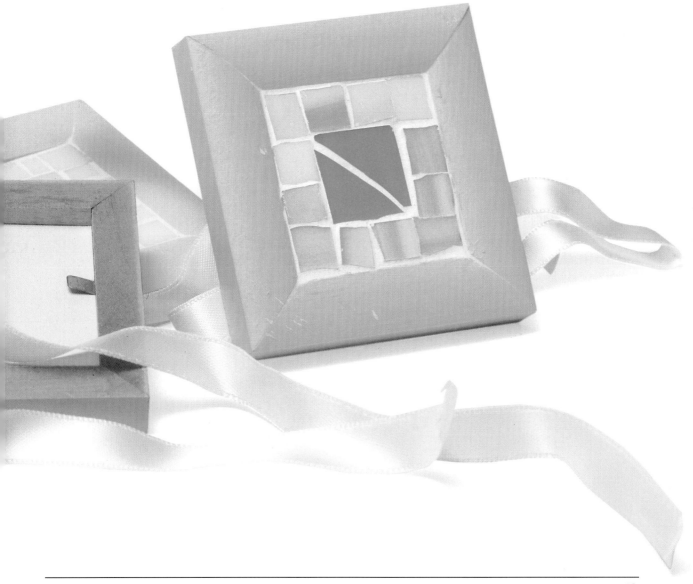

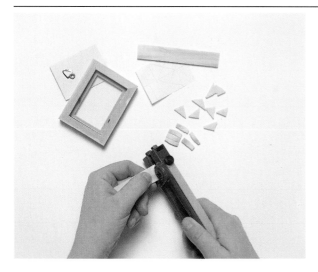

1 Draw an actual-size pattern, and cut the glass pieces.

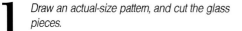

3 In a bowl add a little water to 2 tablespoons of white cement powder, and mix it to make a smooth paste.

2 Prepare the two-component epoxy glue, spread it on the surface, and quickly position the glass pieces.

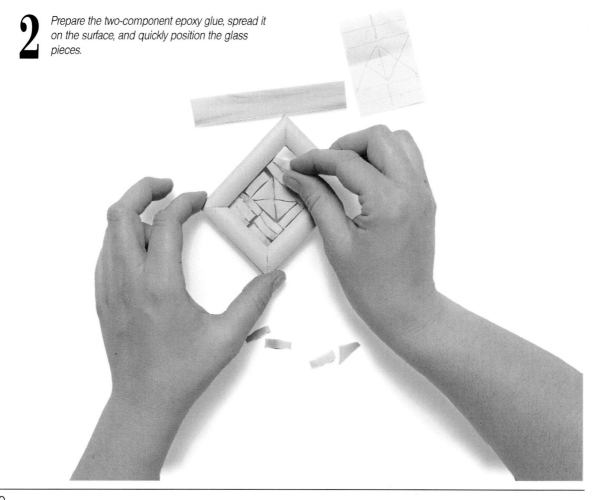

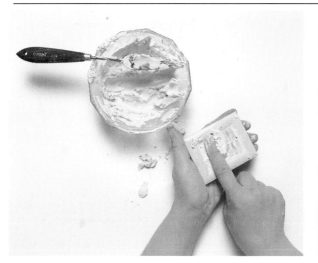
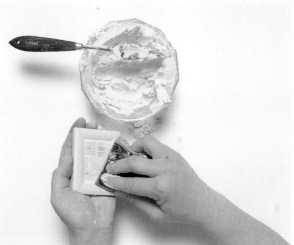

4 *Use your finger to spread the cement over the glass bits, making sure to completely fill in all the gaps.*

Wait about 10 minutes and then clean off the excess cement with a moist sponge. 5

Wait another 30 minutes and then clean the surface, dry it, and polish it. 6

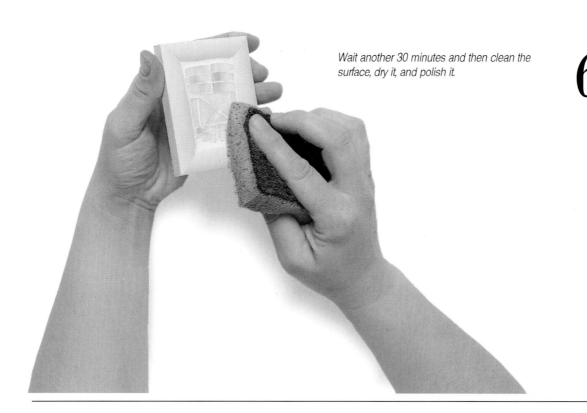

SPICE JAR LID

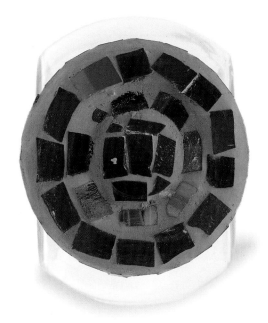

NECESSARY MATERIALS

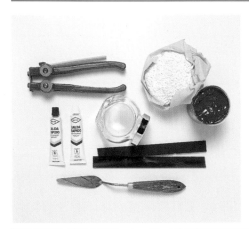

- a spice jar with lid
- red and green glass strips
- mosaic pliers
- two-component epoxy glue
- white cement powder
- pink acrylic paint
- a spatula

*Even an item as simple
as a spice jar can
become a special
treasure if the lid is
decorated in mosaics.
You can create a
matching set of lids or
make each lid unique.*

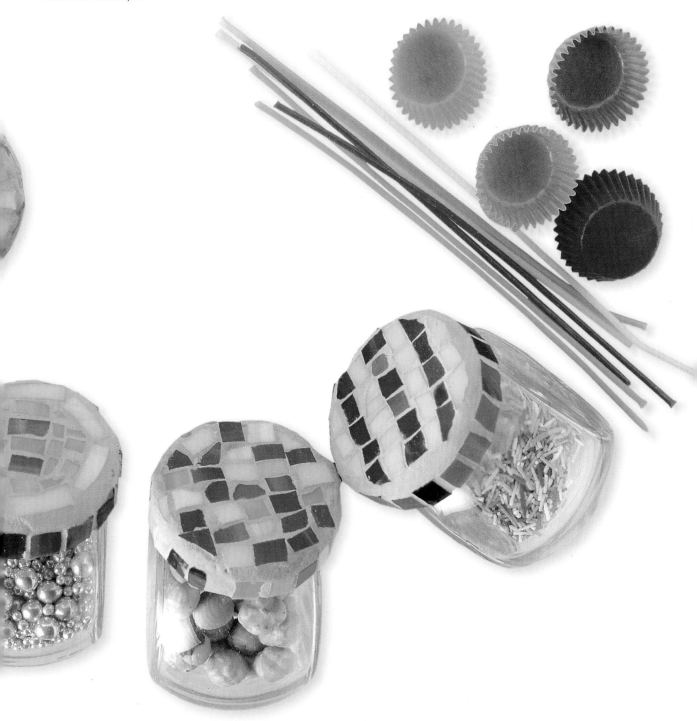

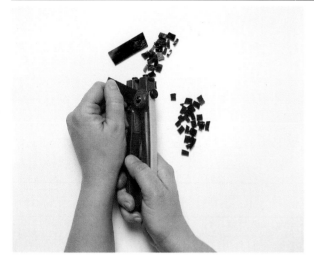

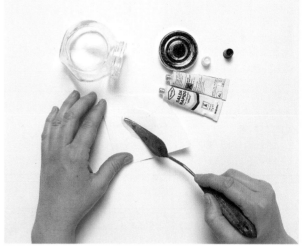

1 *Use the mosaic pliers to cut small rectangular glass pieces.*

Prepare the two-component epoxy glue following the manufacturer's directions. 2

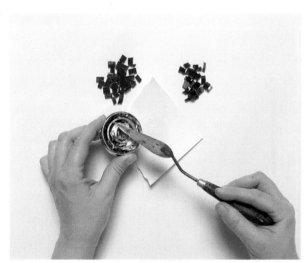

Arrange the glass bits on the lid in a random pattern. 4

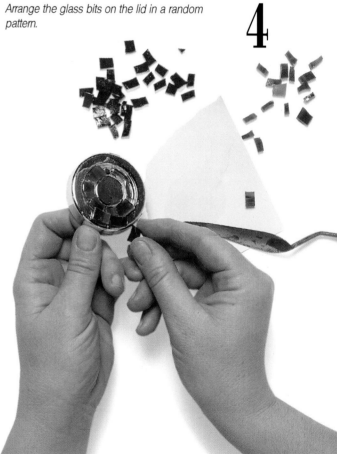

3 *Use a spatula to spread the glue on the outside of the lid.*

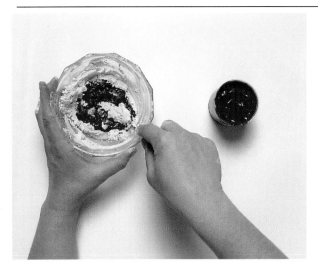

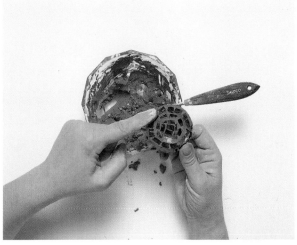

5 Put 2 tbsp of white cement powder and 1 tbsp of pink acrylic paint into a bowl. Slowly add water to make a smooth paste.

Use your finger to spread the cement on the lid, making sure to completely fill in all the gaps. **6**

7 Wait 10 minutes and then clean off the excess cement with a moist sponge. Wait another hour, and then polish the surface with a clean, dry cloth.

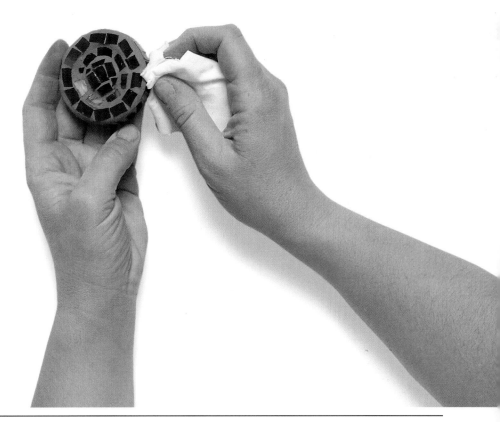

DESIGN IDEAS

BOXES

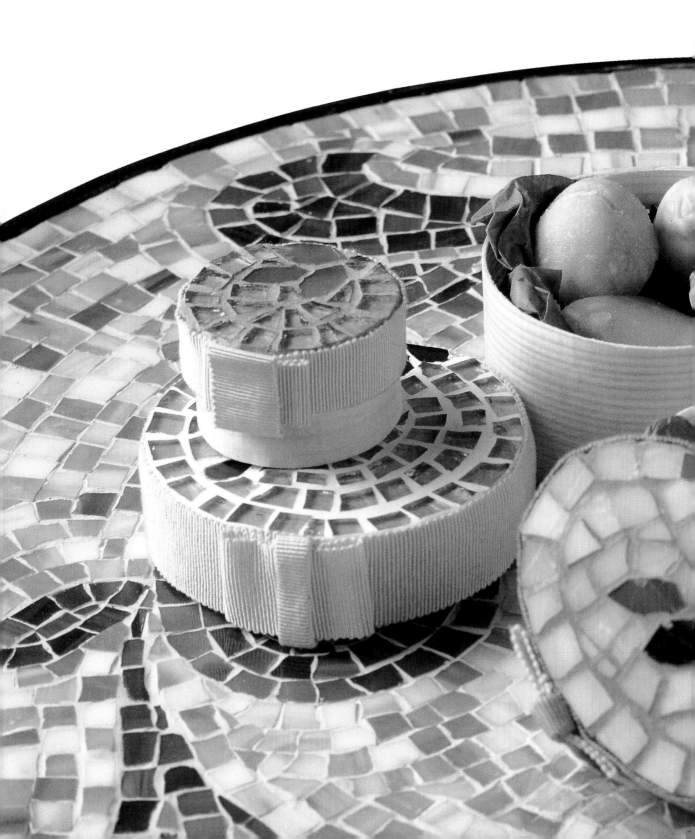

Among all the items suitable for mosaic embellishment, box lids are by far one of the easiest to work with, which makes them an excellent beginner's project. The following pages contain boxes in various shapes and sizes. Most of them were decorated by two artists who combined their skills to make unusual and interesting works inspired by romantic and Art Deco designs.

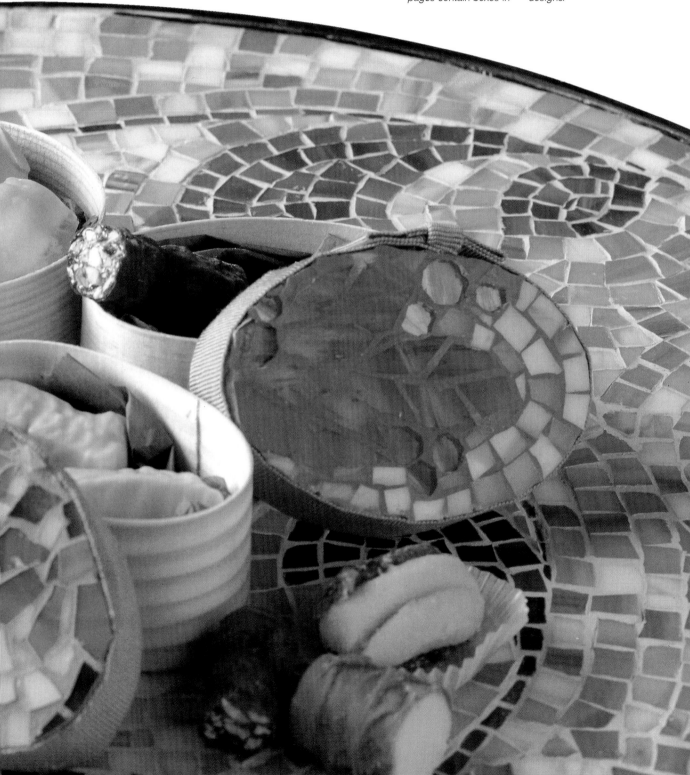

BIG BOXES

*Here is a collection
of large mosaic boxes.
You can fill them with
sweets, stationery, or
sewing notions.*

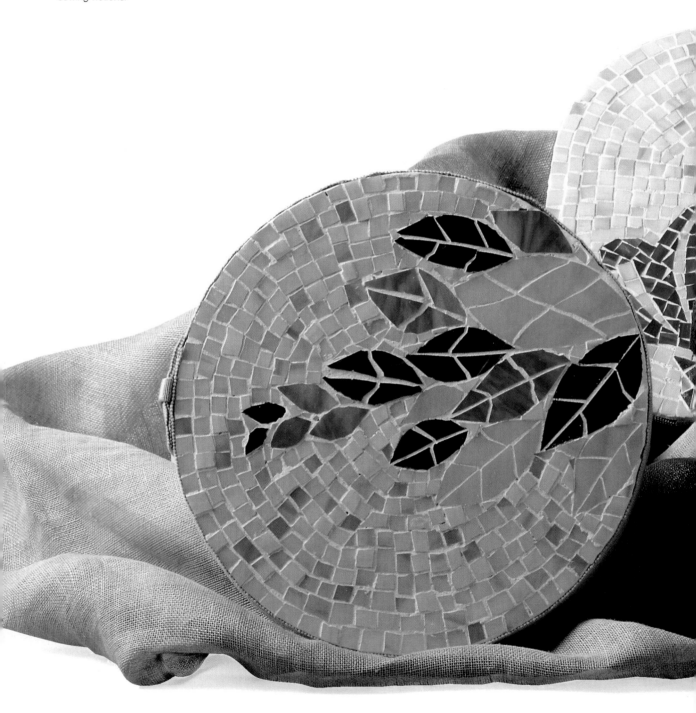

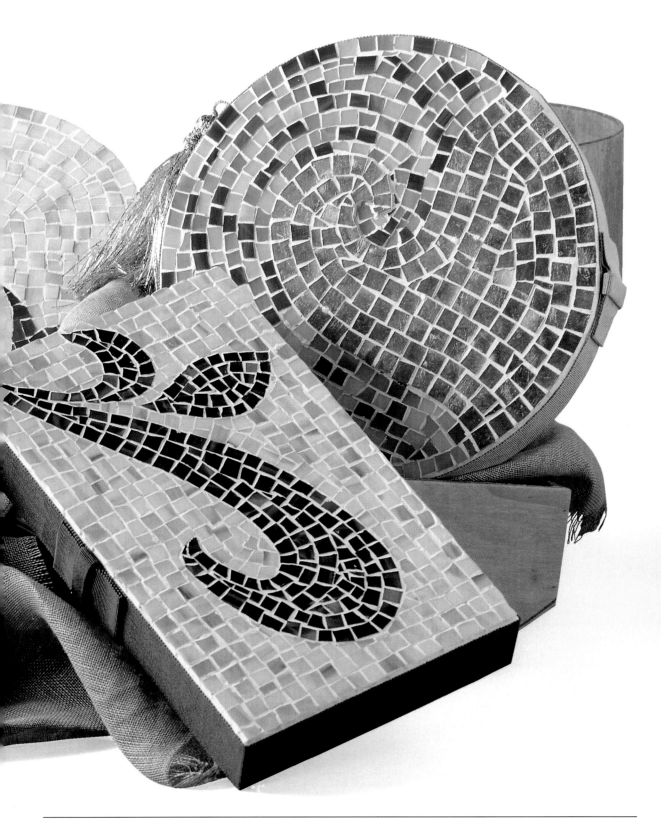

Here is a rectangular box with a whimsical design created in warm tones of deep green and beige. The leaf design was arranged first, and then the background pieces were placed, starting at the edge and working around the leaves.

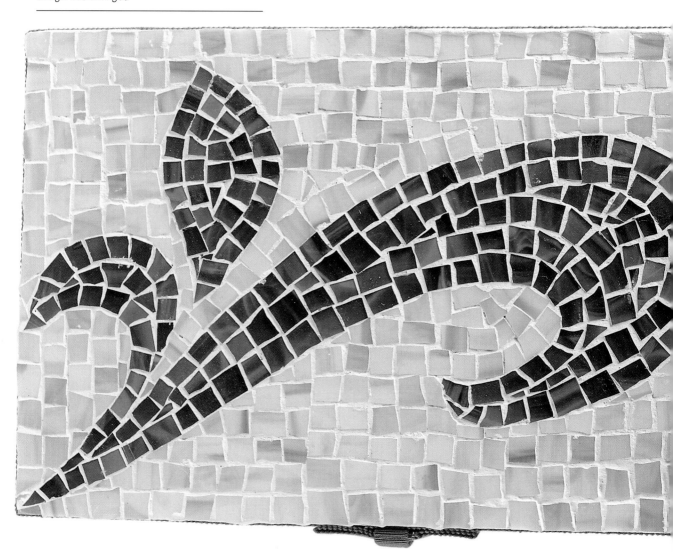

This oval box features a blue-and-gold fleur-de-lis against a background of white squares.

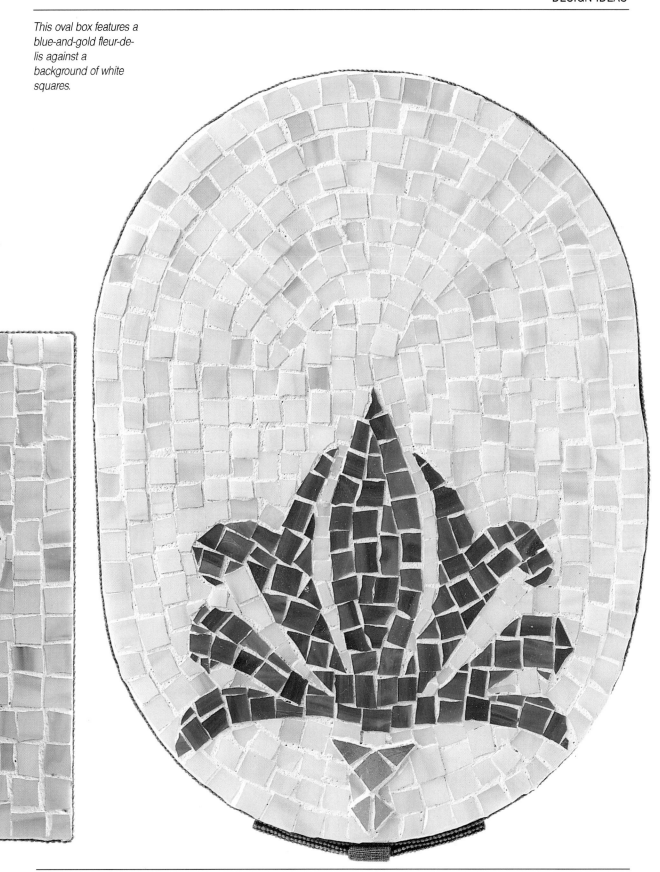

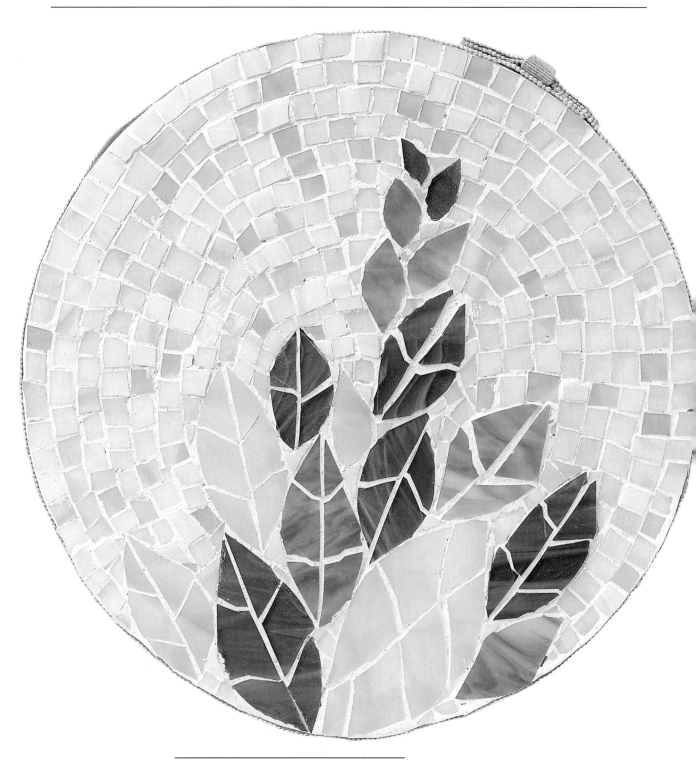

This round box has a
shiny white-and-beige
background that sets off
the sky-blue and forest-
green opalescent
leaves. The glass for the
leaves is cut in large,
irregular pieces.

Here is a round box painted in a washed-out blue. The lid features a gold-leaf wave against a background of assorted blues, and it is reminiscent of classic Greek mosaics.

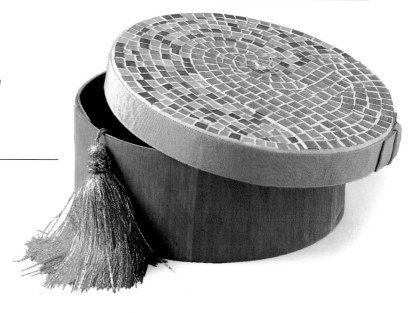

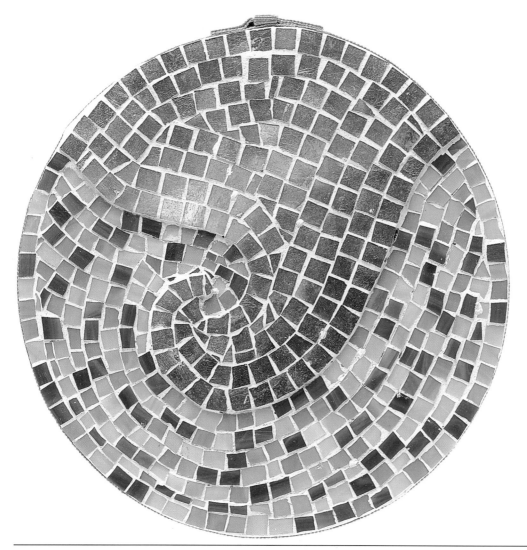

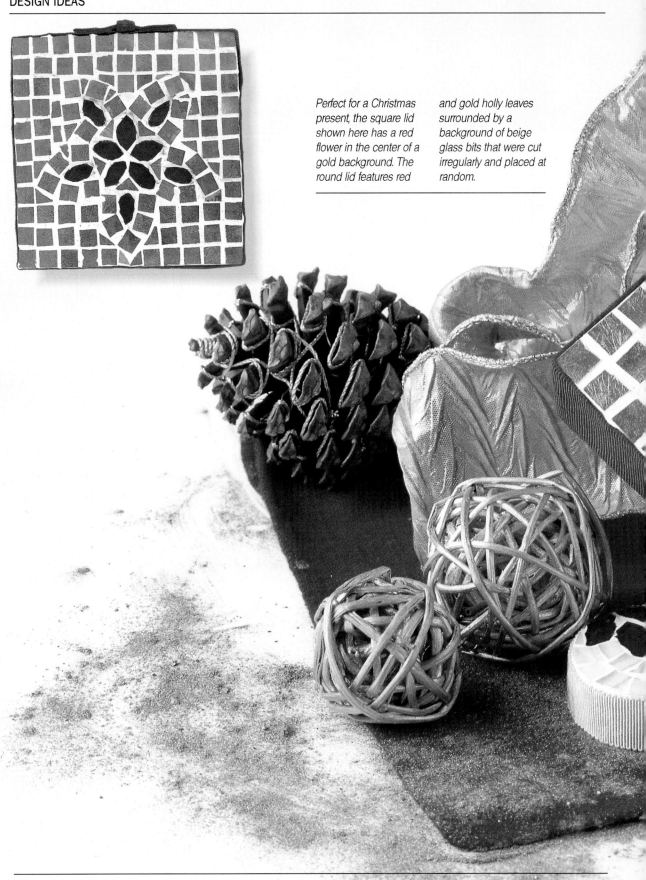

Perfect for a Christmas present, the square lid shown here has a red flower in the center of a gold background. The round lid features red and gold holly leaves surrounded by a background of beige glass bits that were cut irregularly and placed at random.

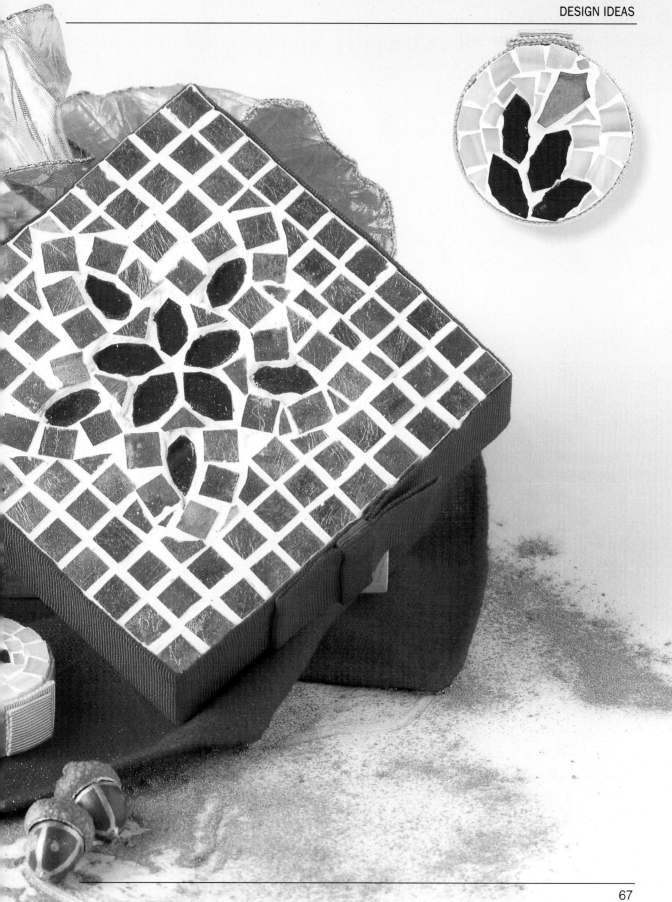

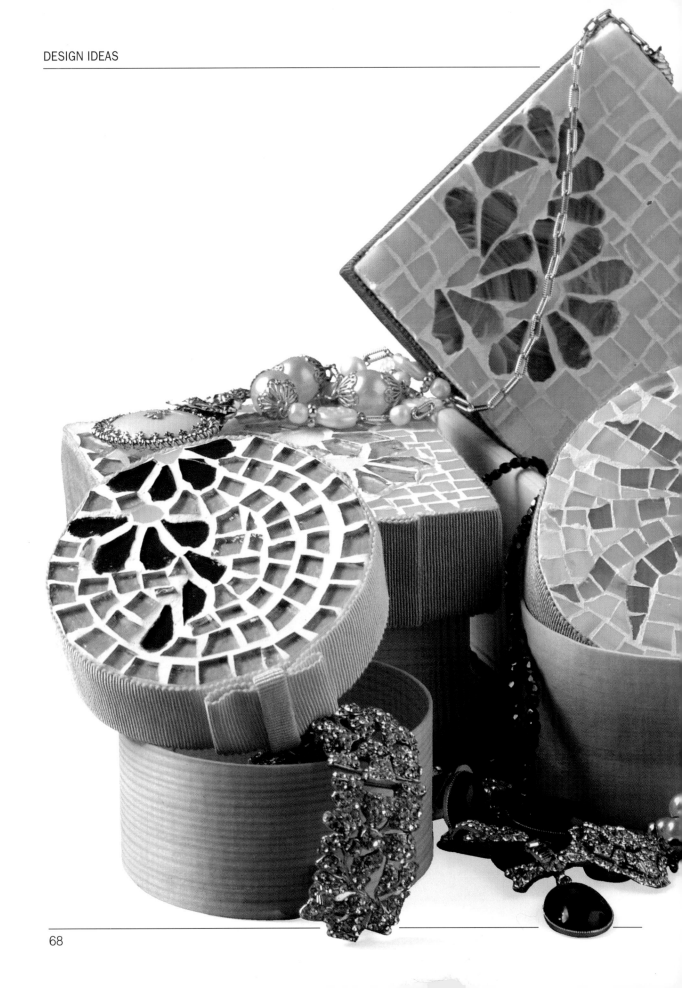

LITTLE BOXES

Here is a group of small boxes that can be used to hold jewelry or other tiny treasures. Each lid sports a bold floral pattern on a light background.

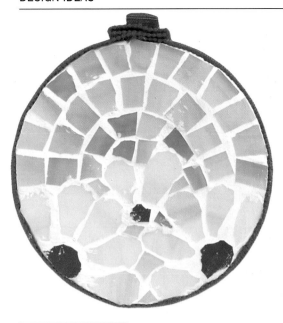

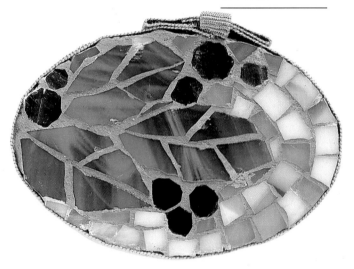

This small oval box has an olive-and-leaf pattern. The cement is dark beige.

This little box features a ribbon border that echoes the red of the daisy center. The background is in shades of blue and gray.

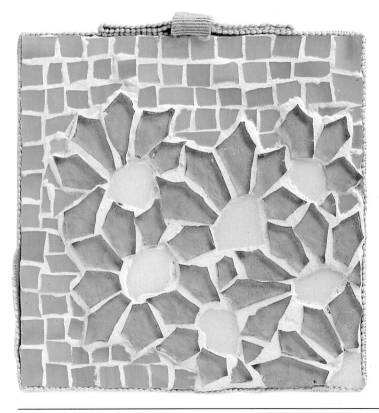

This square box has a simple blue background that sets off a design of gold daisies. The petals are made from painted clear glass, which gives them shadows and depth.

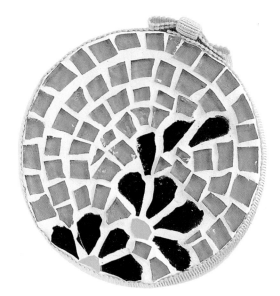

This box is similar to
the oval one on the
opposite page.
It features a floral petal
pattern and repeats the
dark beige cement.

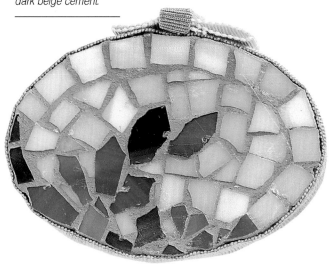

On this tiny round box,
the blue daisy design is
surrounded by gold
background pieces
arranged in a spiral
pattern.

This square box has a
long-petaled daisy
design and a simple
background of cold
greens and blues.

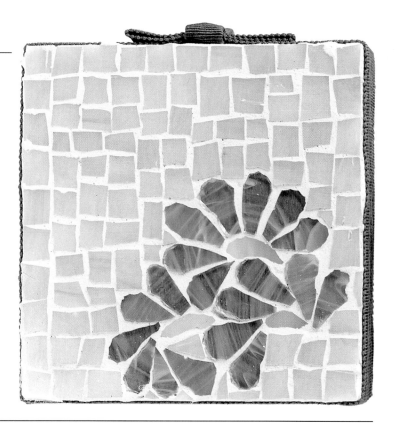

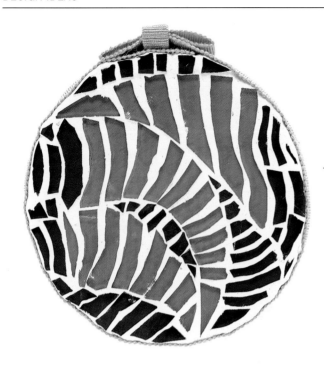

This round box has a wavy design of irregularly shaped glass pieces.

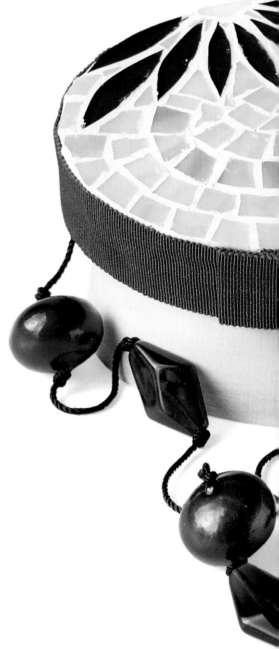

This elegant design has a burst of long, dark blue petals against a simple background of light greens and blues.

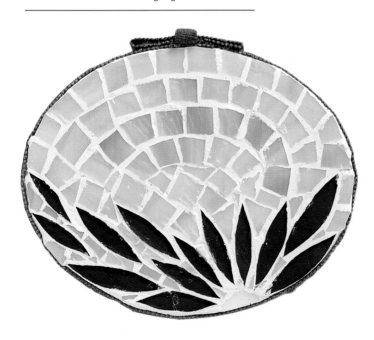

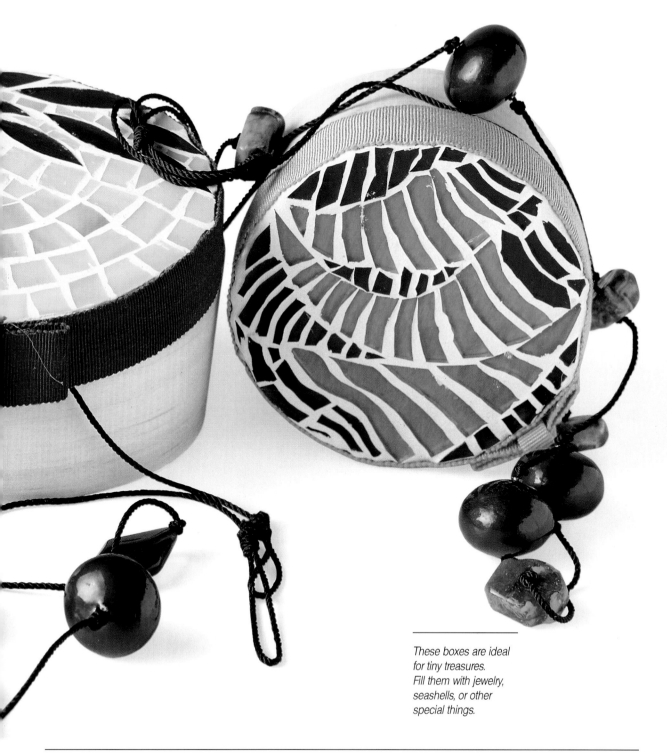

These boxes are ideal
for tiny treasures.
Fill them with jewelry,
seashells, or other
special things.

TABLES

If you enjoy creating geometric designs, making a mosaic table top might be the perfect project for you. The tables in this chapter offer a variety of ideas that you can adapt or use as inspiration for your own unique designs.

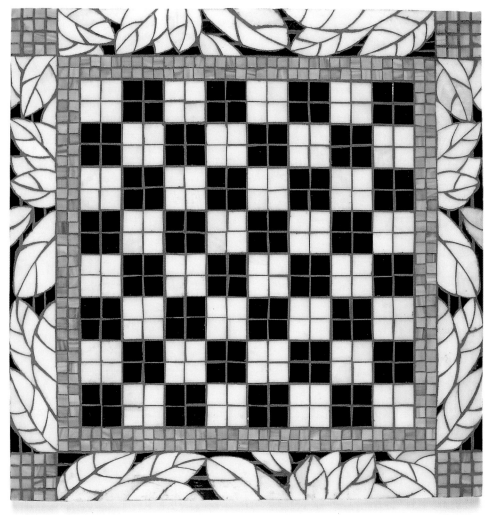

Square base surface 18 inches (45 cm) by 18 inches (45 cm). The black and white pieces are 3/4-inch (2 cm) square to create a chess board. The finishing touch is the leafy border and ochre and blue frame made from smaller glass bits. To make the white glass show up better we used a brown cement to fill in the gaps. The surface was dropped into an iron table frame.

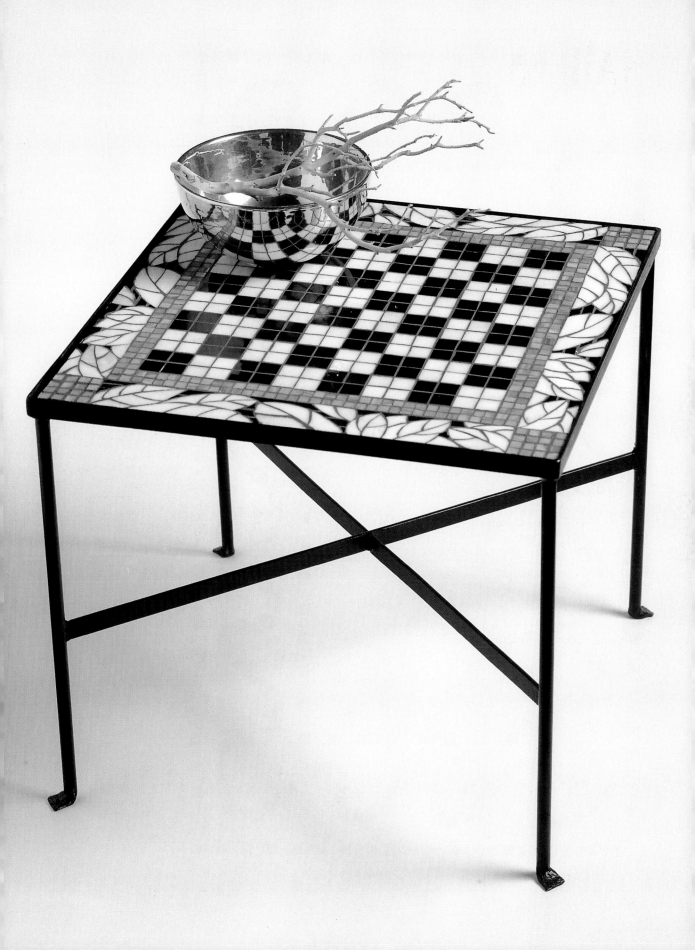

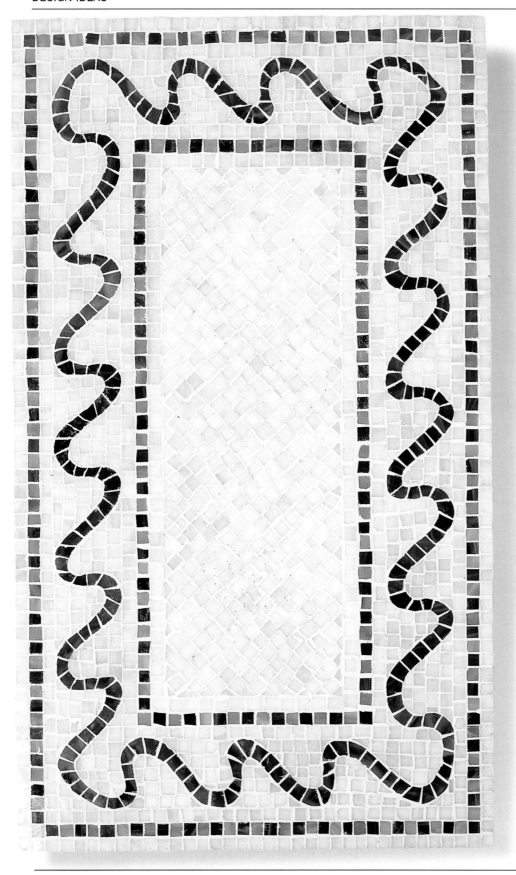

The rectangular shape and contrasting colors of this table give it a classic look. Note that the glass bits in the center are placed on the diagonal.

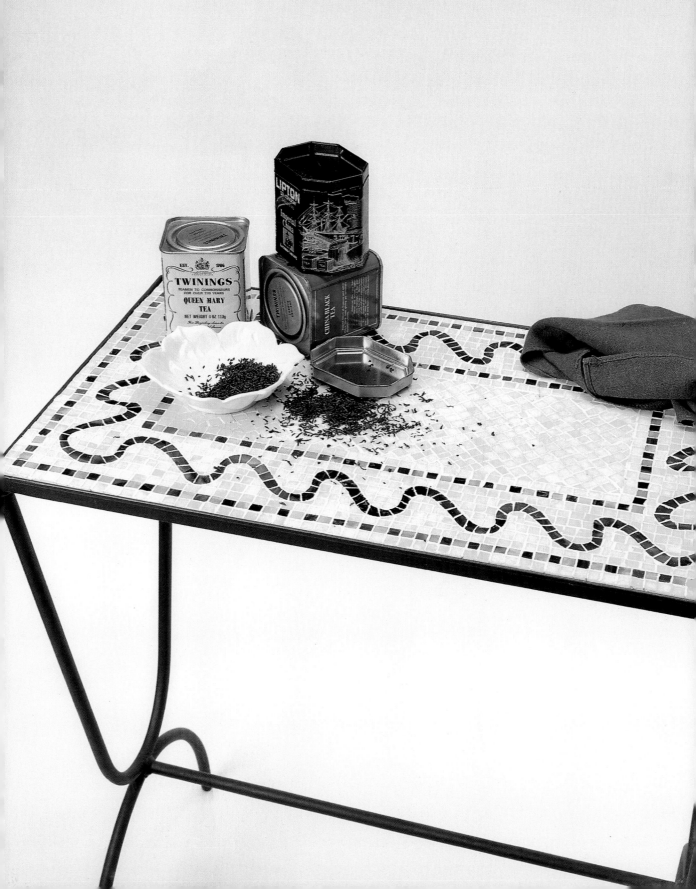

This casual tray, which sits on a folding stand, can become a decorative display piece with the addition of mosaics. It has a simple but effective geometric design with most of the glass squares placed on the diagonal.

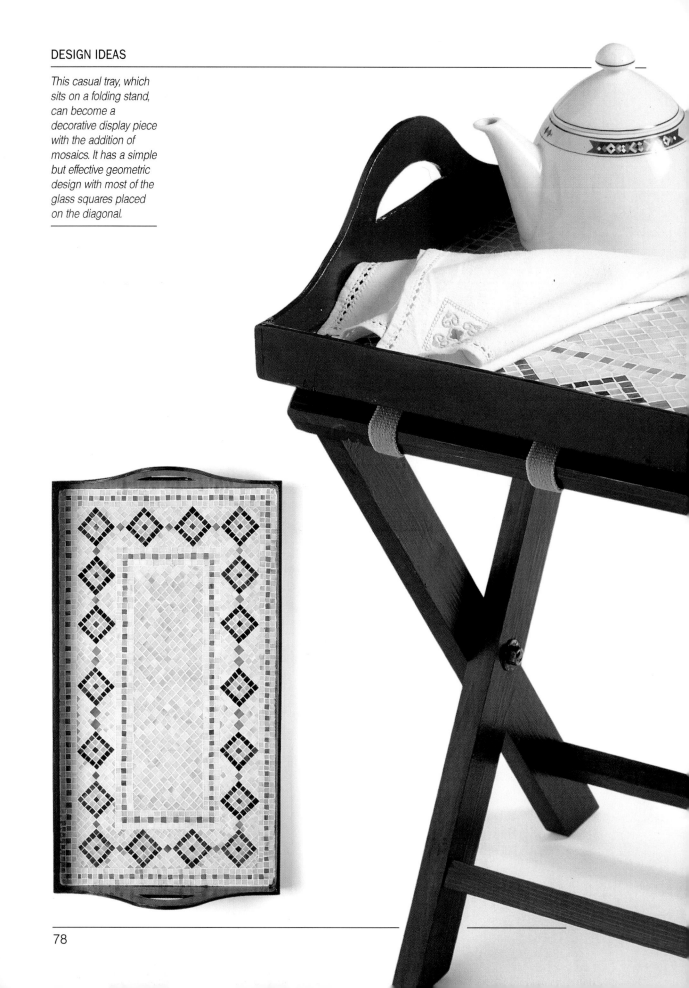

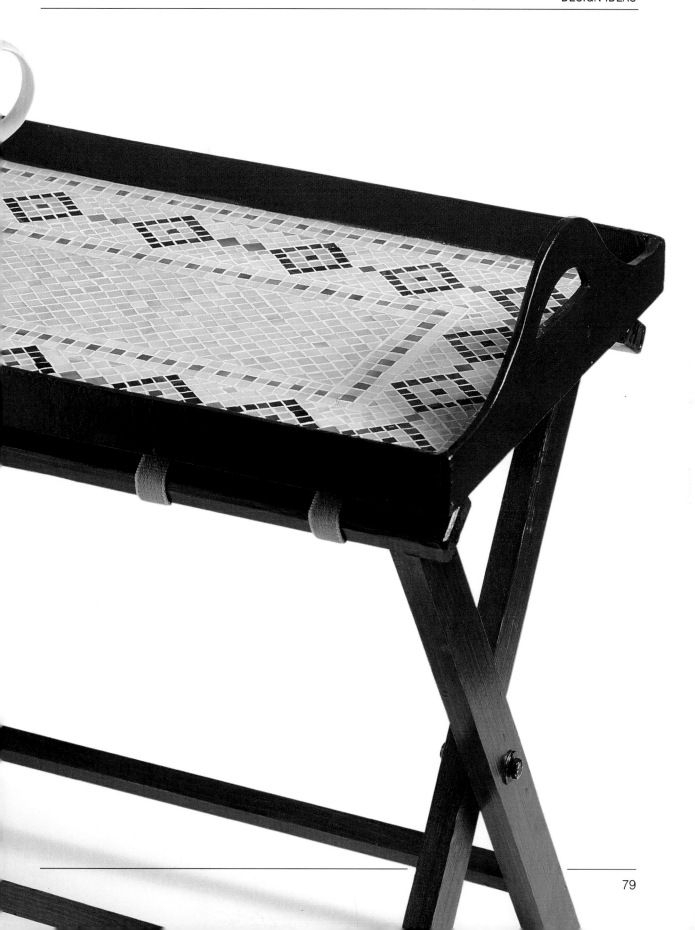

This whimsical floral design requires a lot of patience and an actual-size pattern. The design was glued on first, and then the background of random white and deep orange glass bits was added.

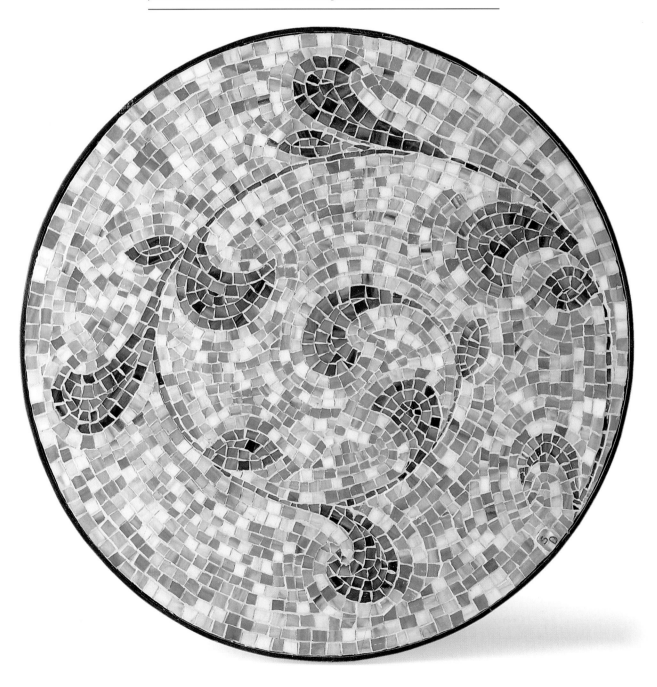

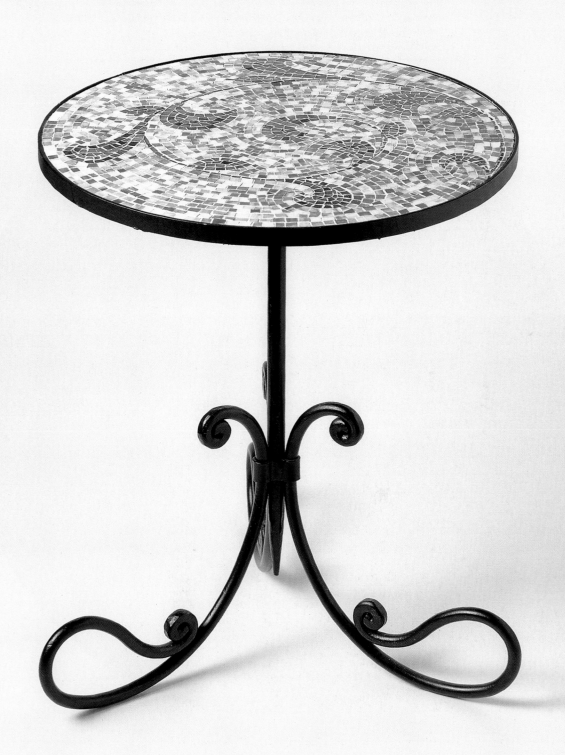

This little occasional table was once a simple wood stool from a thrift shop. Its top was completely covered in metallic gold leaf, and then clear glass squares were added, allowing the gold to show through. White cement colored with blue paint was added to fill in the gaps.

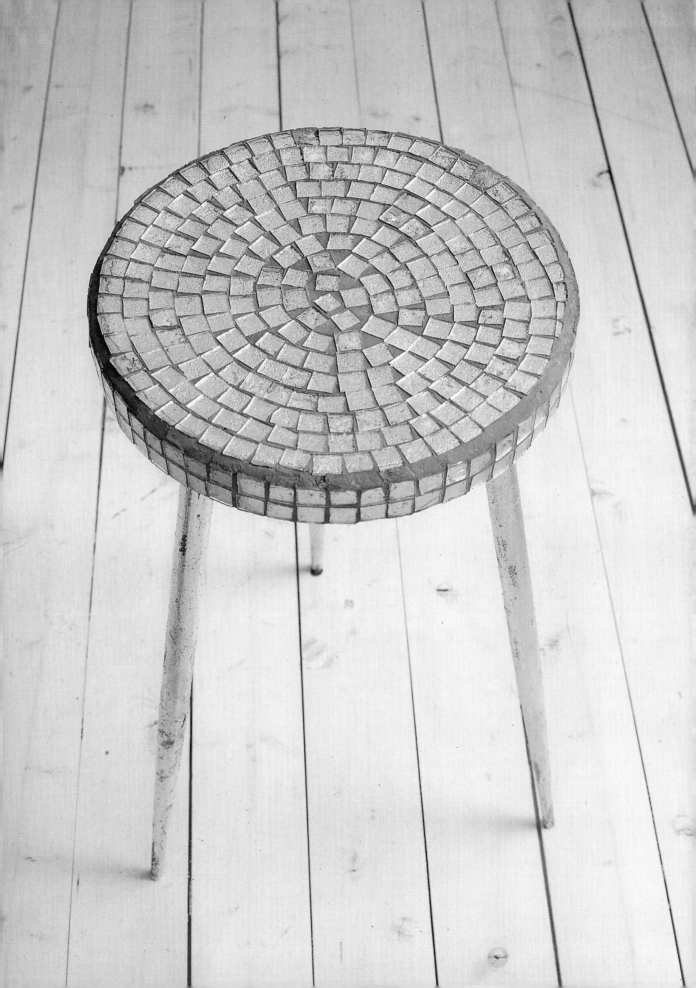

This table was decorated with bits of broken plates, which were then reassembled and attached to the surface with tile glue. Black cement was used to fill in the gaps between the brightly colored plate pieces, giving the mosaic a stained glass look.

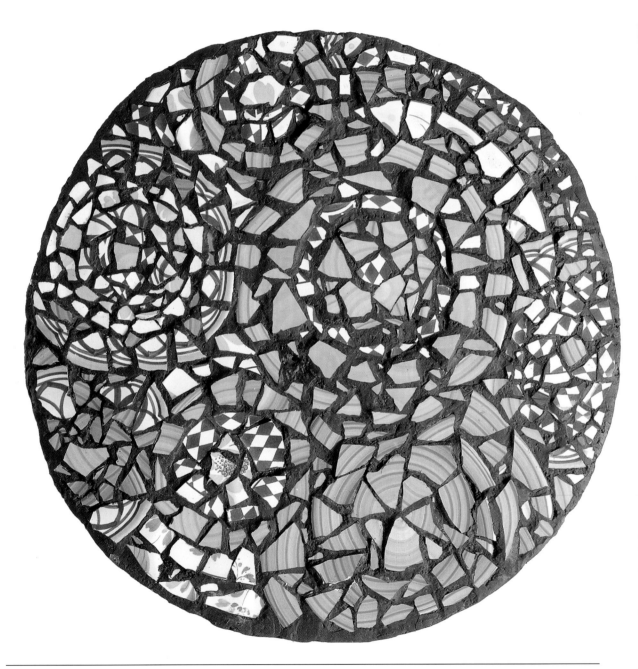

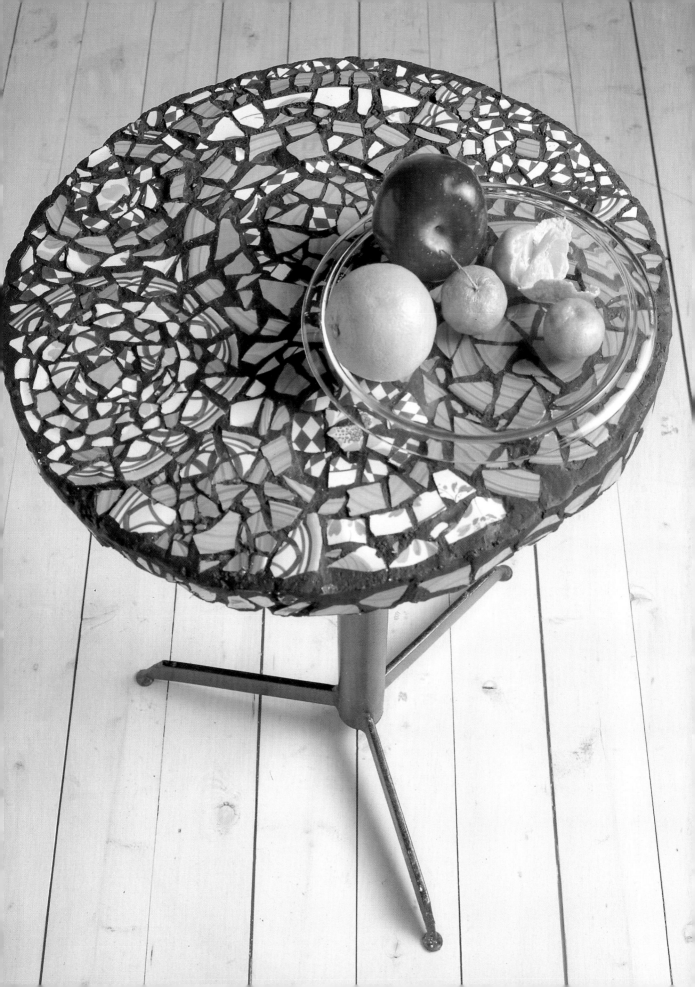

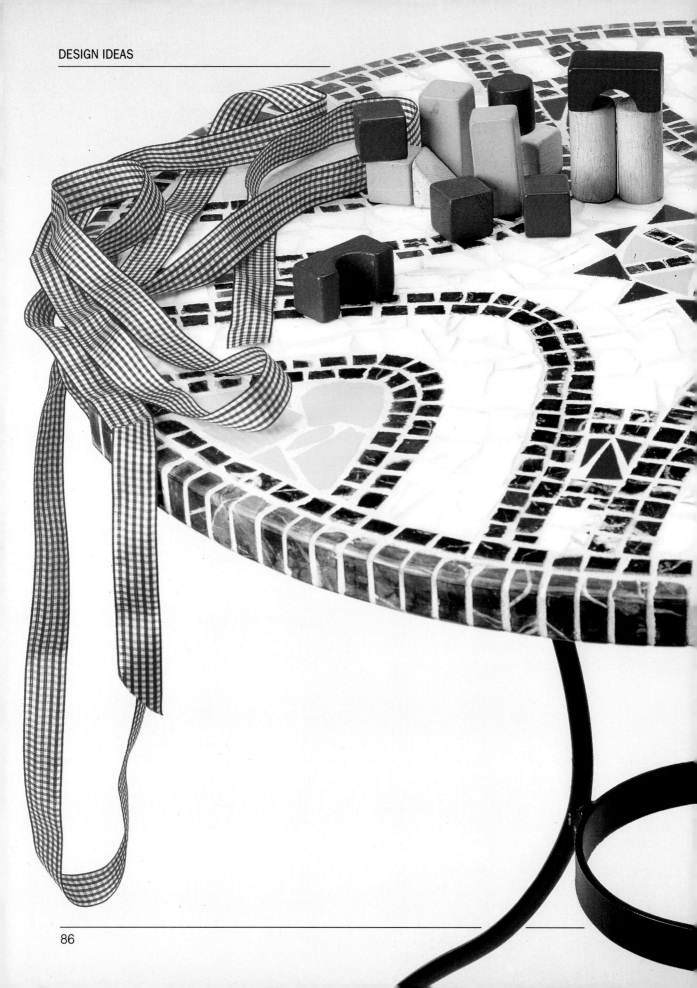

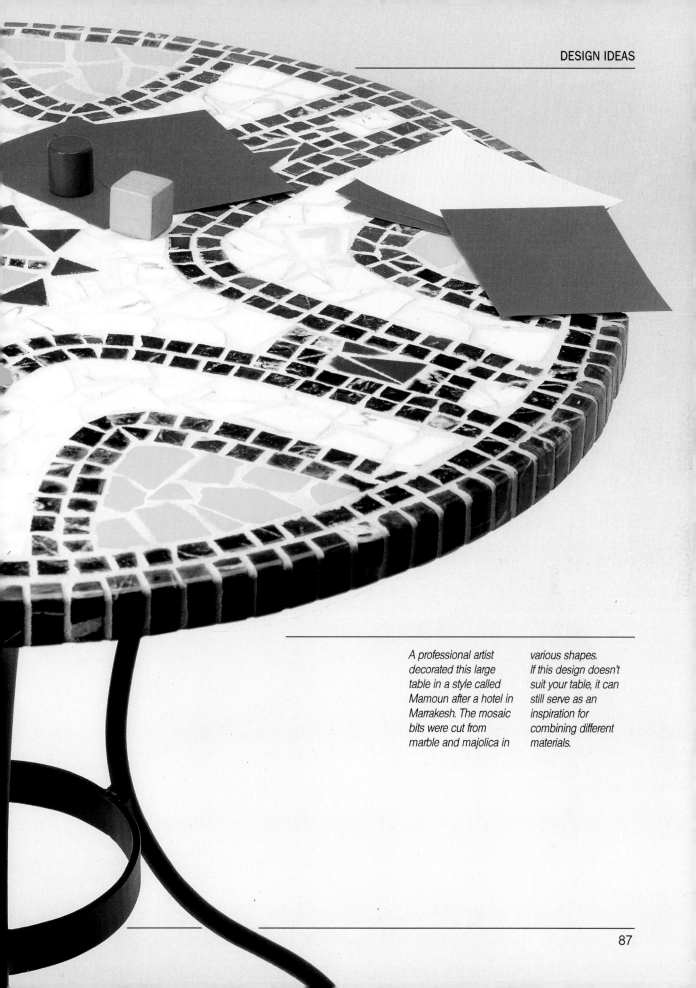

A professional artist decorated this large table in a style called Mamoun after a hotel in Marrakesh. The mosaic bits were cut from marble and majolica in various shapes. If this design doesn't suit your table, it can still serve as an inspiration for combining different materials.

FRAMES

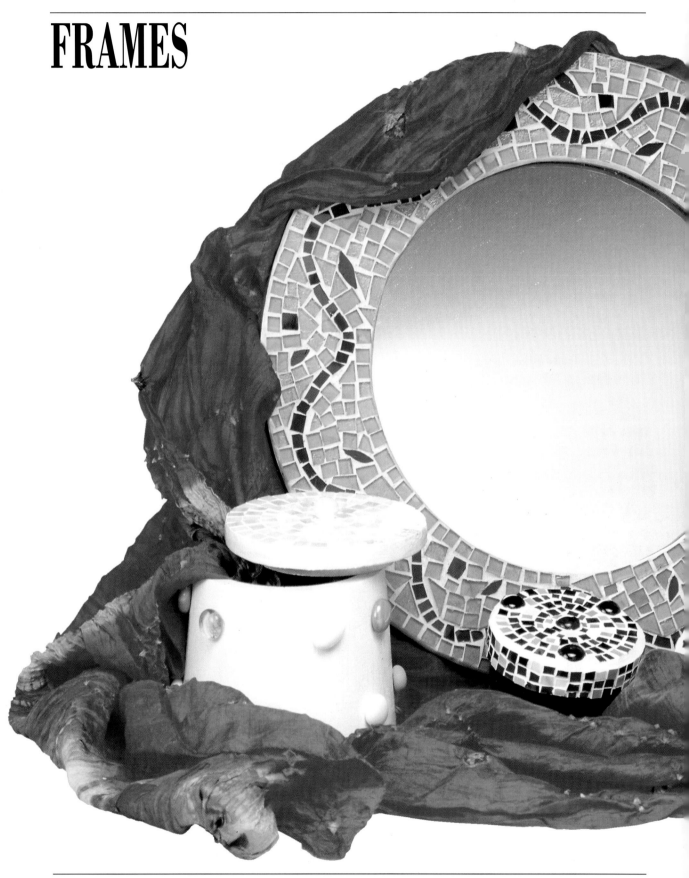

Mosaic frames, beautiful in themselves, can be used to enhance mirrors, photographs, and pictures. Use frames you have on hand, buy a new or used one or a frame kit, or have your frames custom-built. Wood frames work best.

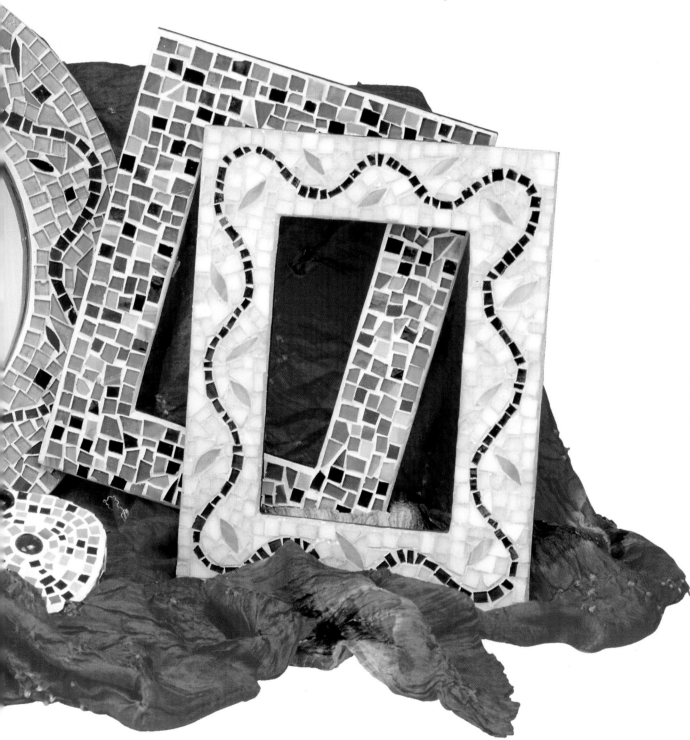

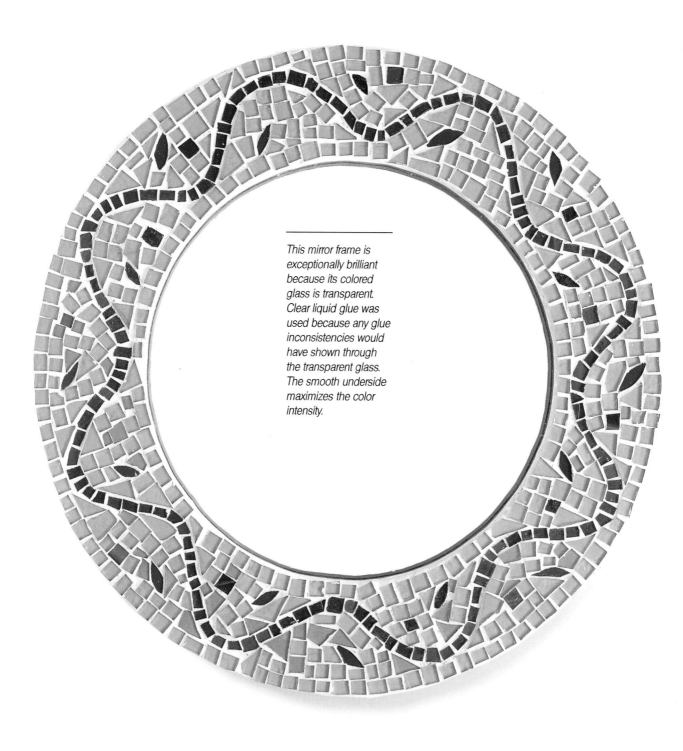

This mirror frame is exceptionally brilliant because its colored glass is transparent. Clear liquid glue was used because any glue inconsistencies would have shown through the transparent glass. The smooth underside maximizes the color intensity.

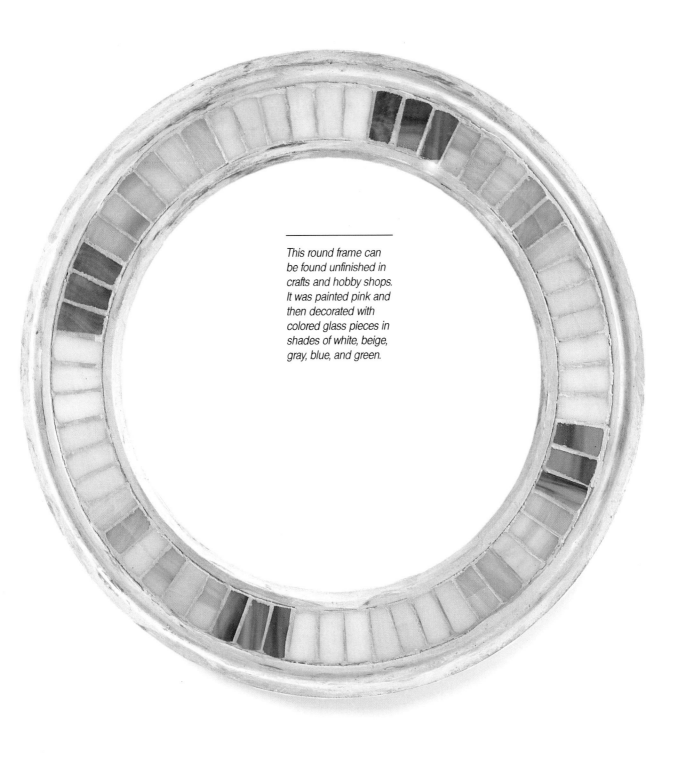

This round frame can
be found unfinished in
crafts and hobby shops.
It was painted pink and
then decorated with
colored glass pieces in
shades of white, beige,
gray, blue, and green.

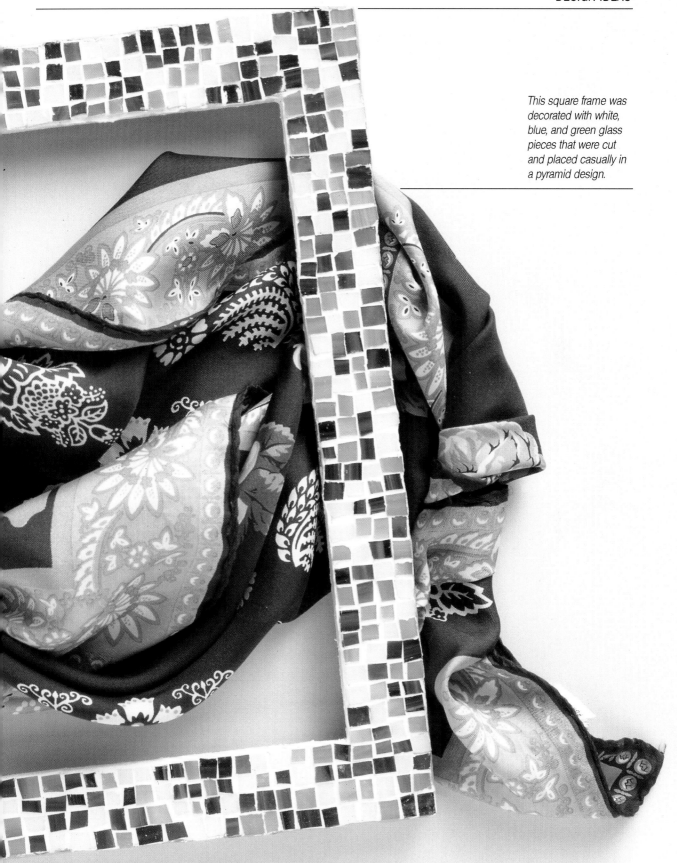

This square frame was decorated with white, blue, and green glass pieces that were cut and placed casually in a pyramid design.

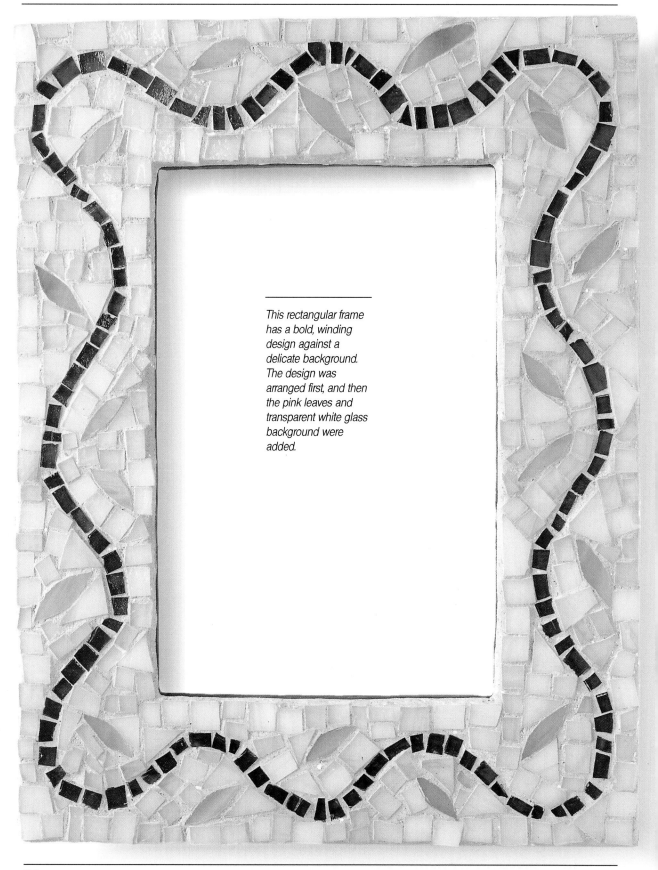

This rectangular frame
has a bold, winding
design against a
delicate background.
The design was
arranged first, and then
the pink leaves and
transparent white glass
background were
added.

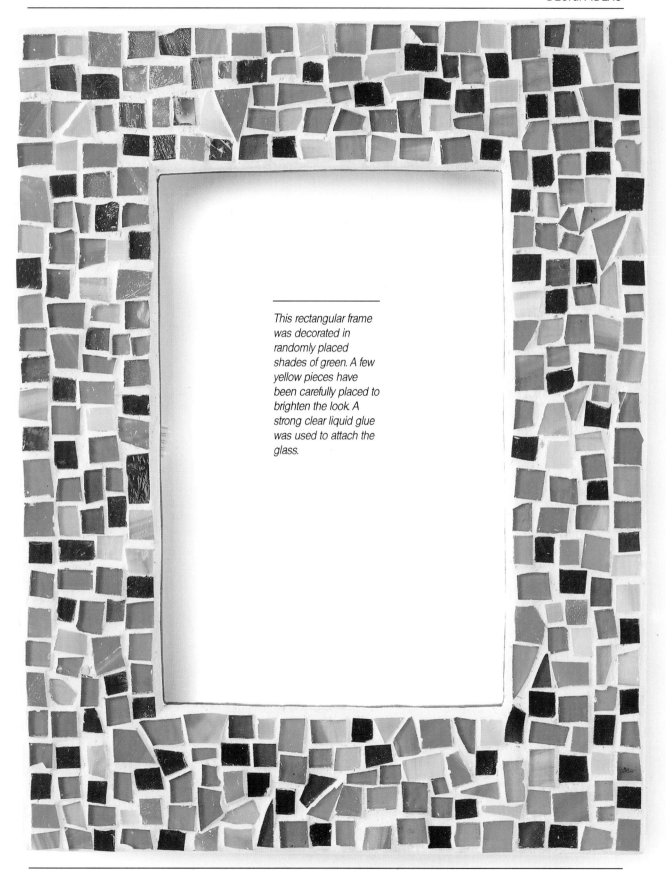

This rectangular frame
was decorated in
randomly placed
shades of green. A few
yellow pieces have
been carefully placed to
brighten the look. A
strong clear liquid glue
was used to attach the
glass.

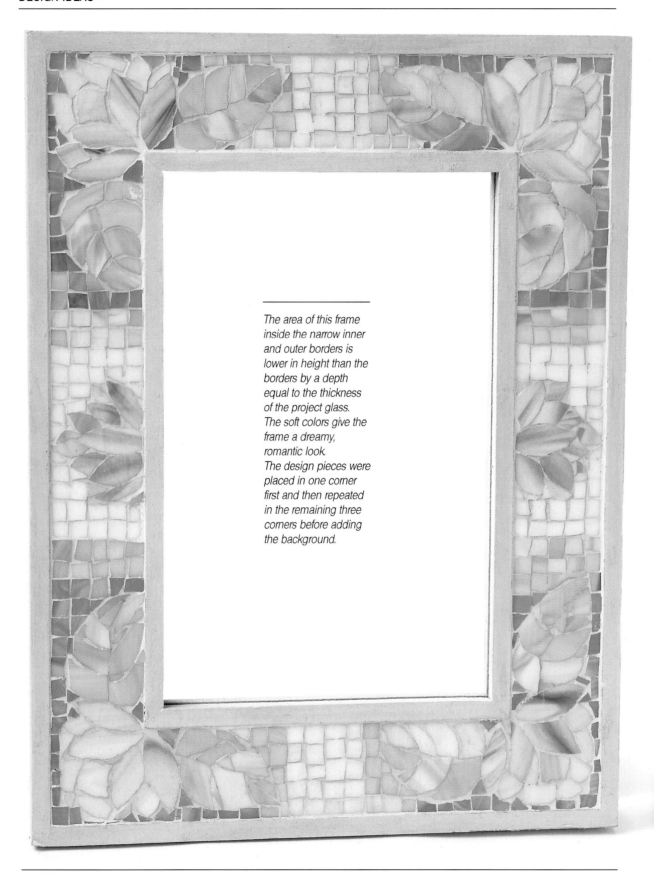

The area of this frame inside the narrow inner and outer borders is lower in height than the borders by a depth equal to the thickness of the project glass. The soft colors give the frame a dreamy, romantic look. The design pieces were placed in one corner first and then repeated in the remaining three corners before adding the background.

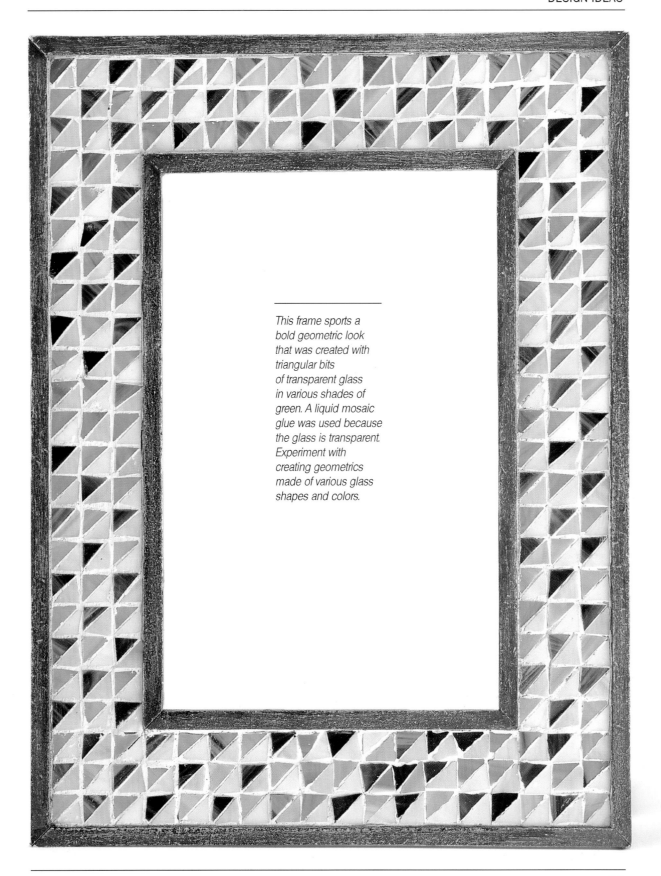

This frame sports a
bold geometric look
that was created with
triangular bits
of transparent glass
in various shades of
green. A liquid mosaic
glue was used because
the glass is transparent.
Experiment with
creating geometrics
made of various glass
shapes and colors.

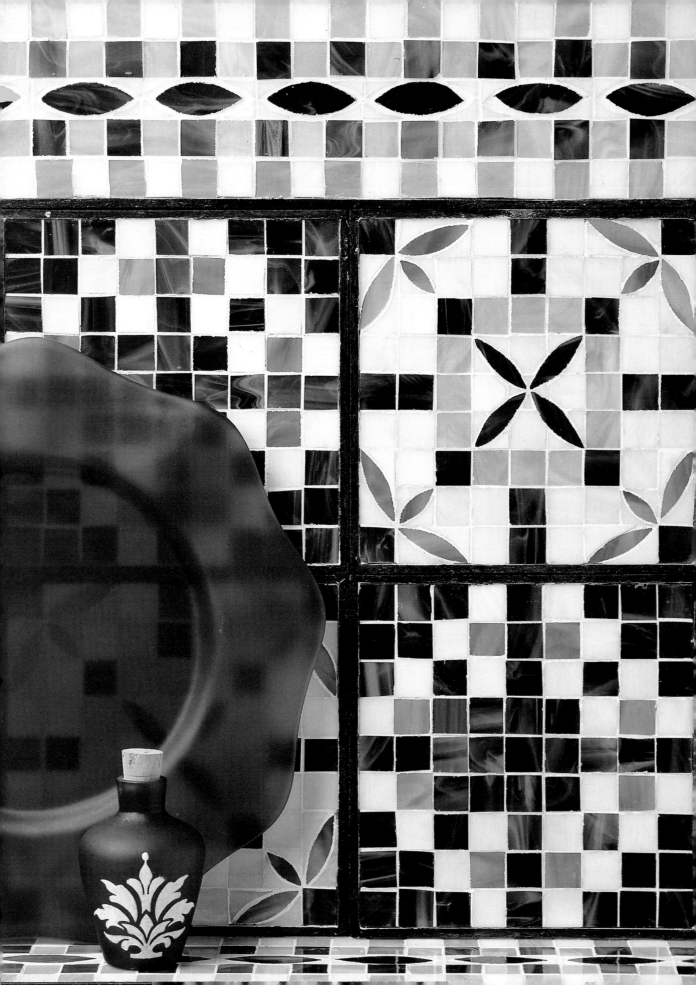

DECORATING IDEAS

This chapter presents just a taste of what you can do with glass mosaic. There are no limits to the creative possibilities. If you want to decorate something large, such as a floor or wall, be sure to draw an actual-size pattern and thoroughly plan your project before beginning it, to prevent any unpleasant surprises as you work. All the designs shown here were created on pre-existing structures.

Close-up of a ceramic tile covered in glass mosaic.

These decorative tiles can brighten any kitchen and make it feel fresh and new. The diamond-shaped tile is covered with colored glass and colored cement. Experiment with color!

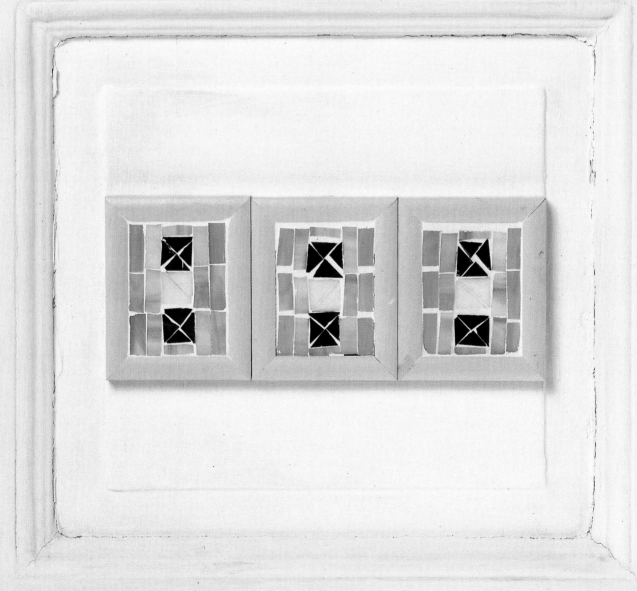

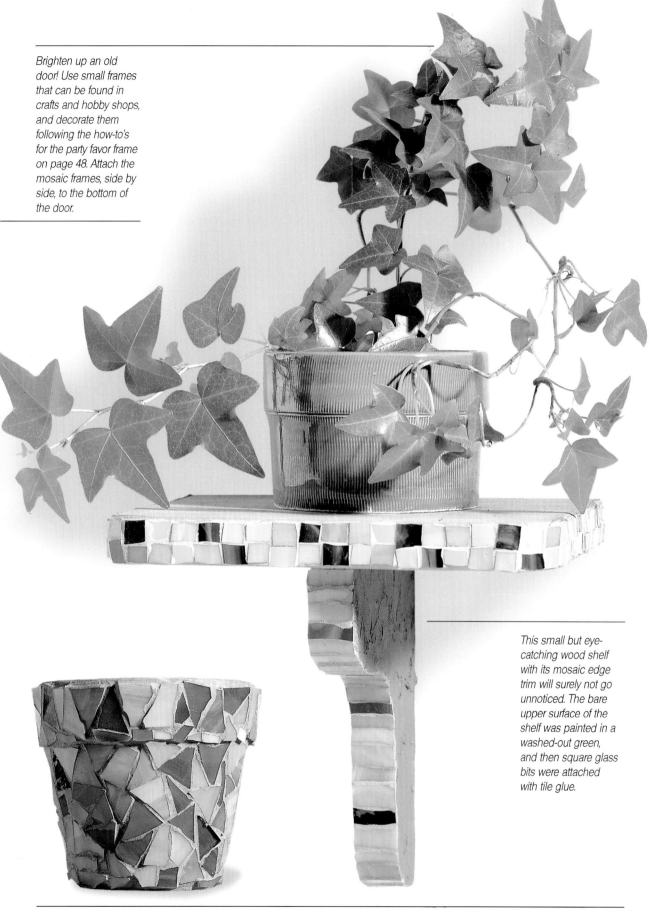

Brighten up an old door! Use small frames that can be found in crafts and hobby shops, and decorate them following the how-to's for the party favor frame on page 48. Attach the mosaic frames, side by side, to the bottom of the door.

This small but eye-catching wood shelf with its mosaic edge trim will surely not go unnoticed. The bare upper surface of the shelf was painted in a washed-out green, and then square glass bits were attached with tile glue.

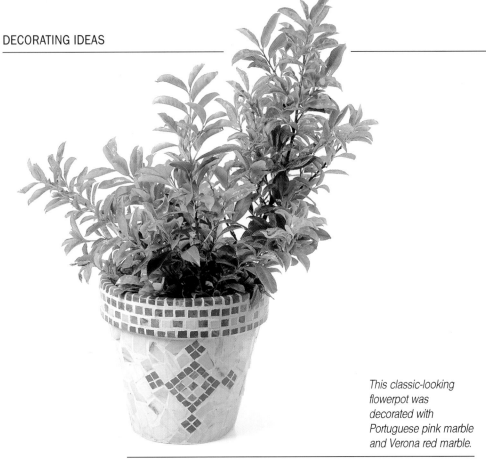

*This classic-looking
flowerpot was
decorated with
Portuguese pink marble
and Verona red marble.*

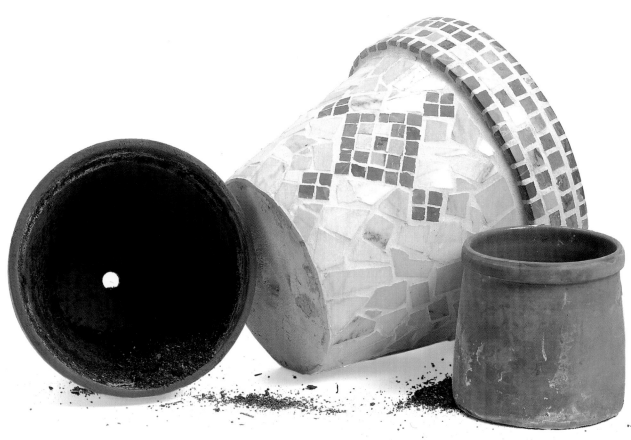

Terra-cotta pots are readily available and fun to decorate. You can attach randomly shaped and placed pieces in one color or many colors. You can use shells, stones, or buttons to add a unique touch to your flowerpot.

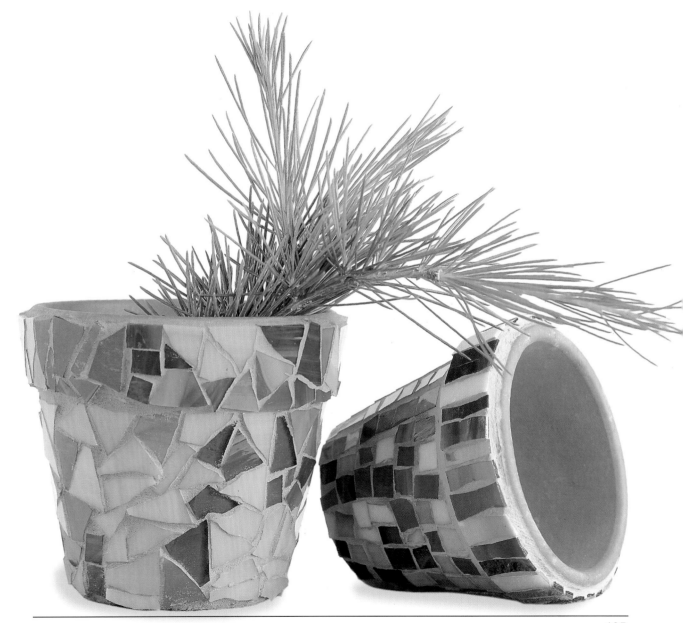

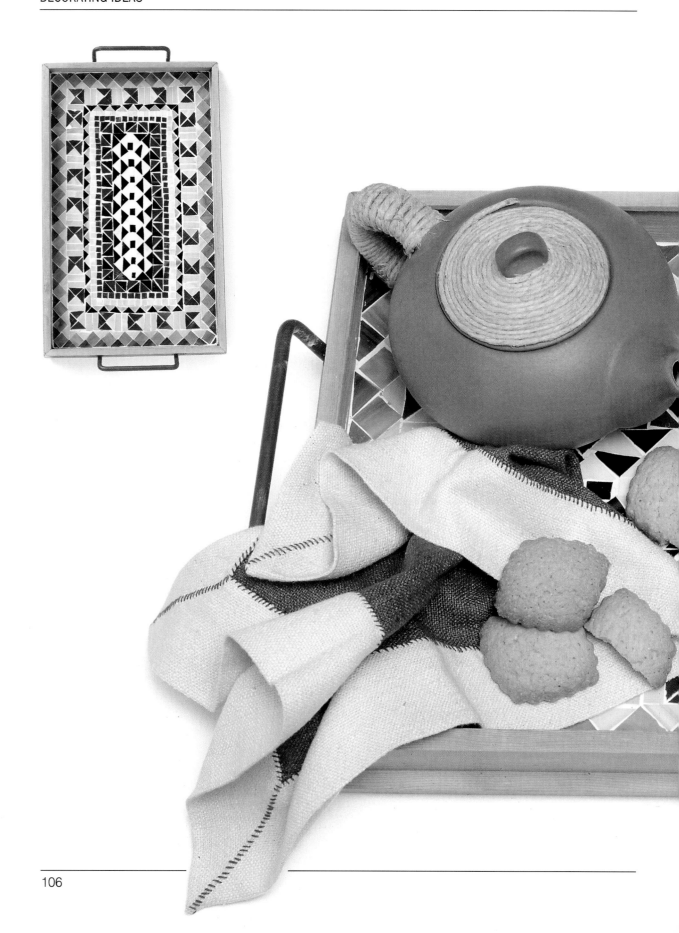

This rectangular tray features a bold design in the same colors that were used on the terracotta bowl project that begins on page 30.

The design was traced directly onto the tray, and the glass was glued on with a strong clear liquid glue.

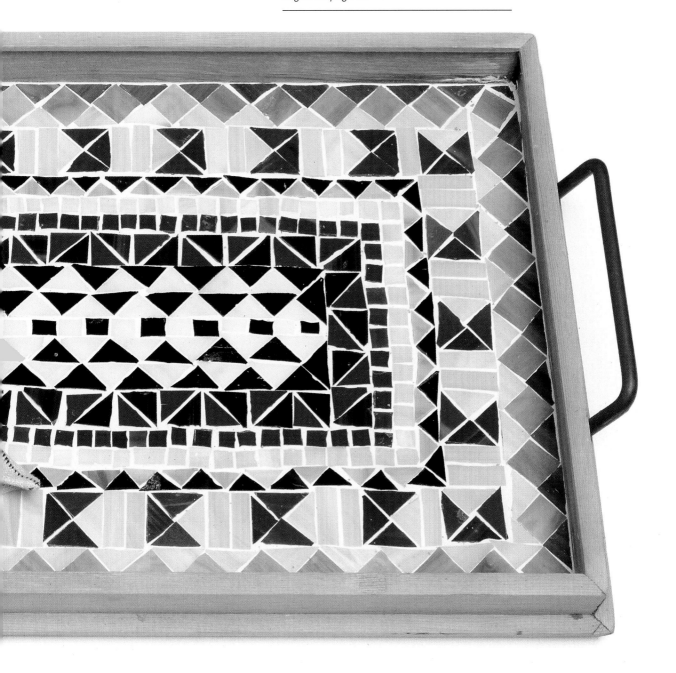

SMALL PROJECTS

This chapter is designed to get your creative juices flowing. A little bit of embellishment added to everyday items can transform them into beautiful gifts that were quick and easy to make. For most of the following projects the two-component epoxy glue was used because the items are quite small.

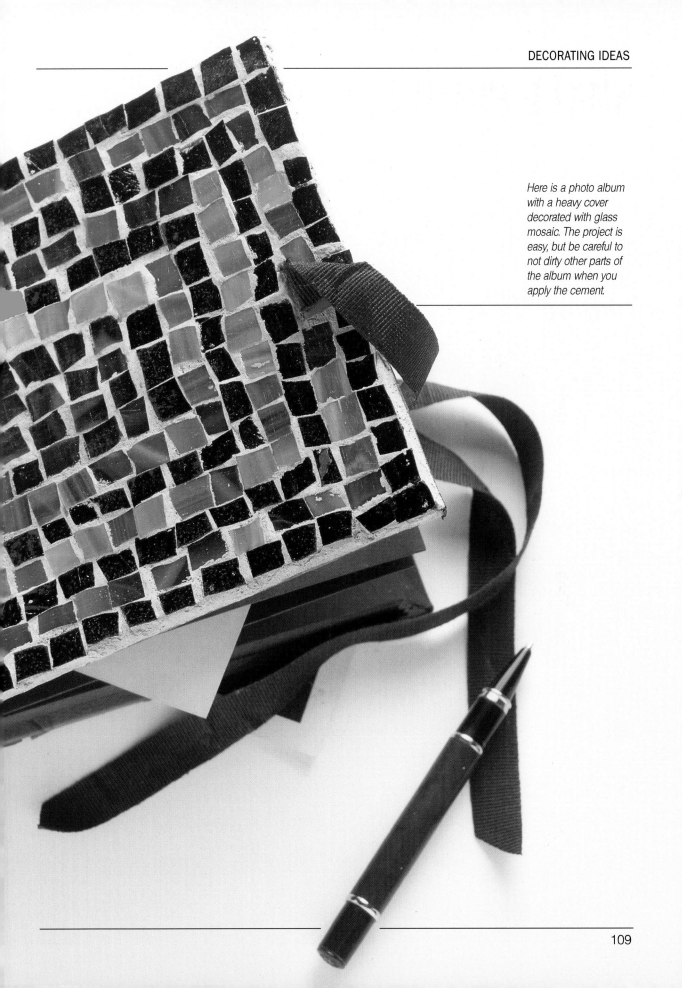

Here is a photo album with a heavy cover decorated with glass mosaic. The project is easy, but be careful to not dirty other parts of the album when you apply the cement.

Napkin rings can be found in all colors and materials, so why not in mosaic? The napkin rings shown here have no indented area in which to place the glass bits, so be especially careful when you apply the cement borders.

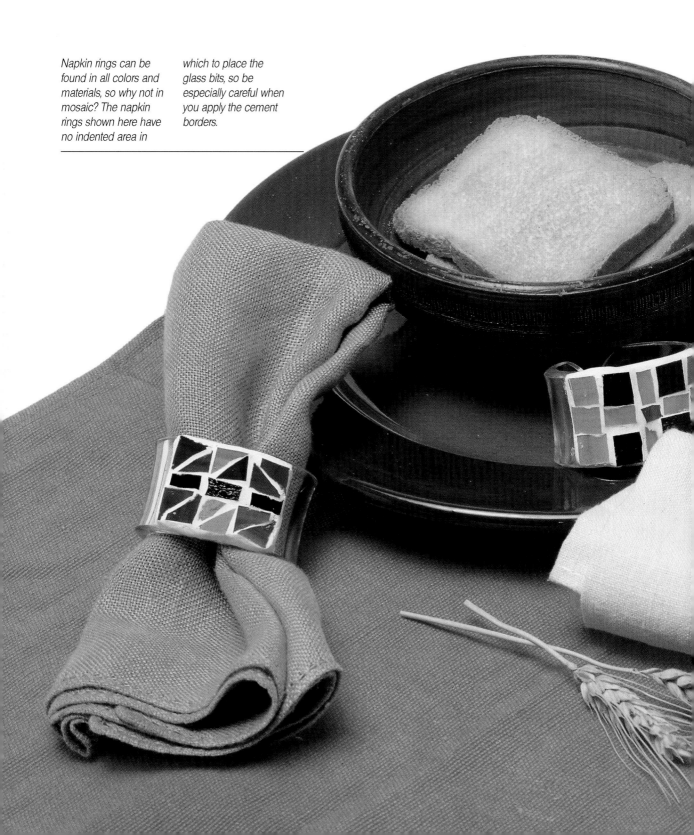

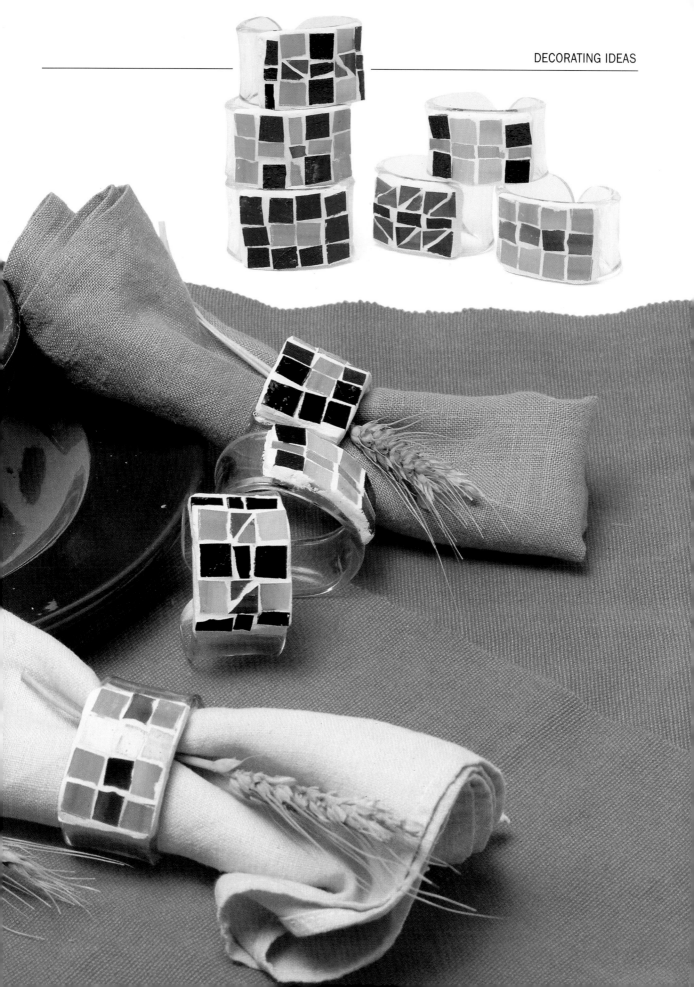

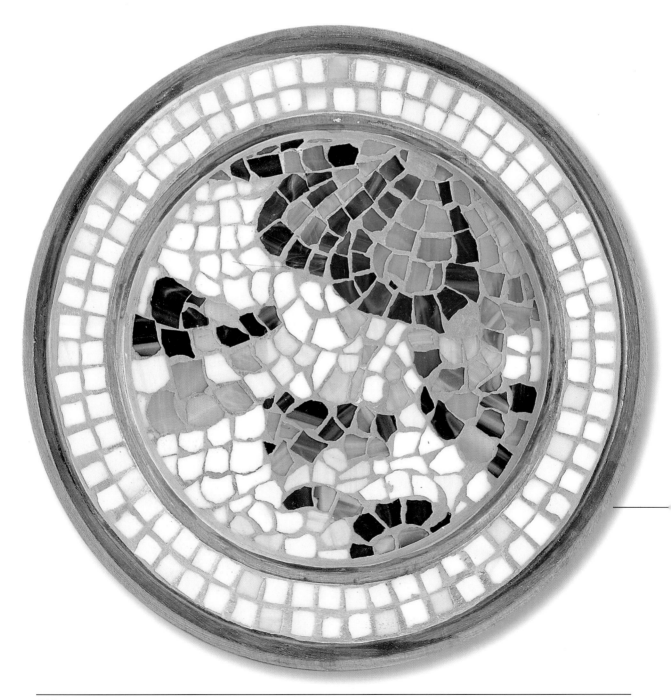

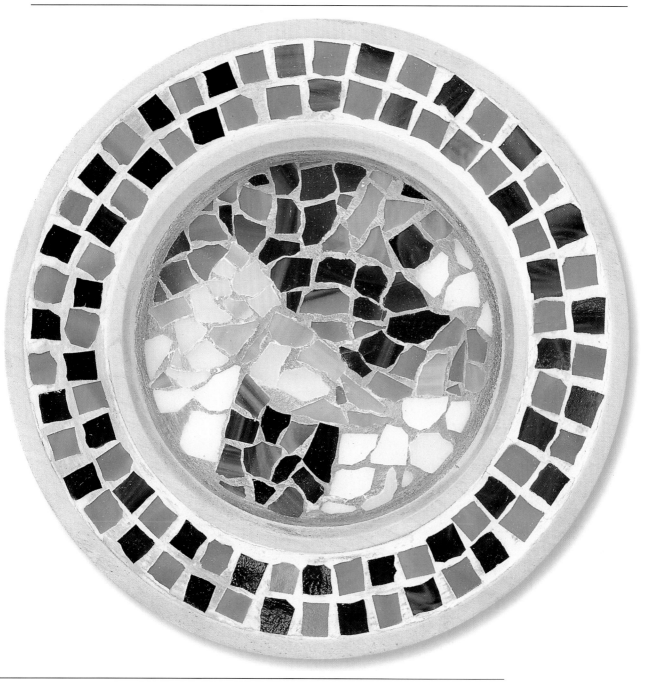

Here is a pair of small wood trays decorated in the same colors but with different designs. They were purchased unfinished and ready for decorating. Each tray has a double frame, which is just right for adding a mosaic border.

This terra-cotta dish was intended to be used under a flowerpot when it was purchased unfinished. It was decorated with a blue spiral design and finished with a blue cement that was colored with acrylic paint. Regular tile glue was used.

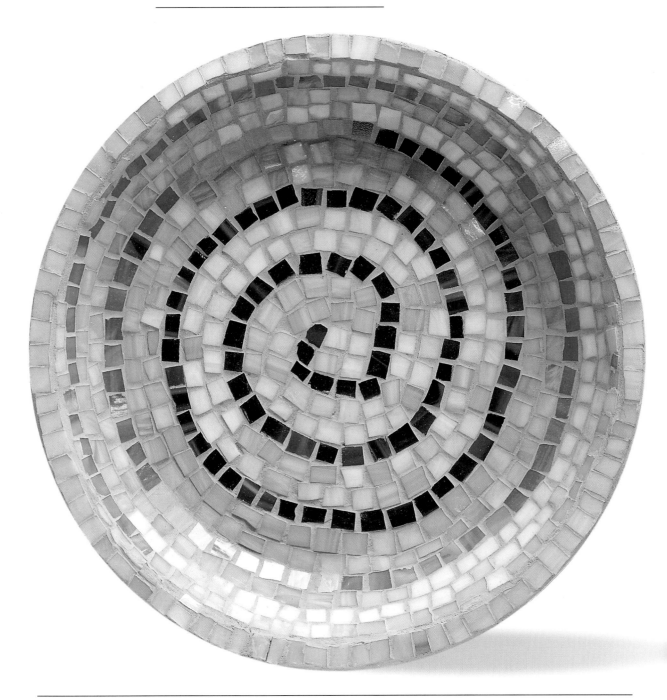

This trivet was made from a square piece of wood with a raised border. The glass squares were positioned starting with the outermost row first and working inward to the center.

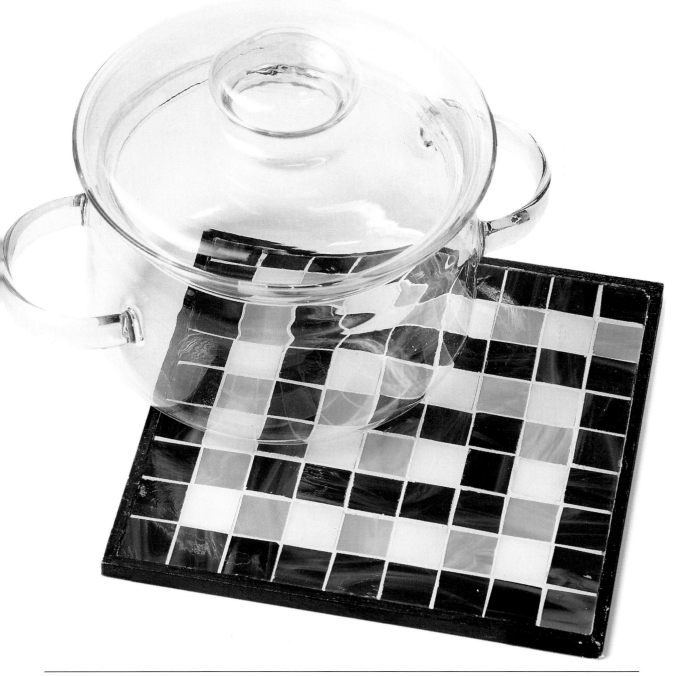

PARTY FAVOR FRAMES

Here are six different variations of a cute gift idea for your party or wedding guests.
All of the frames were decorated with muted pastel colors and a white cement. Only geometric designs are shown here, but you can also create hearts, stars, flowers, or initials.

These small wood boxes can also be interesting party favors, especially when filled with little goodies.

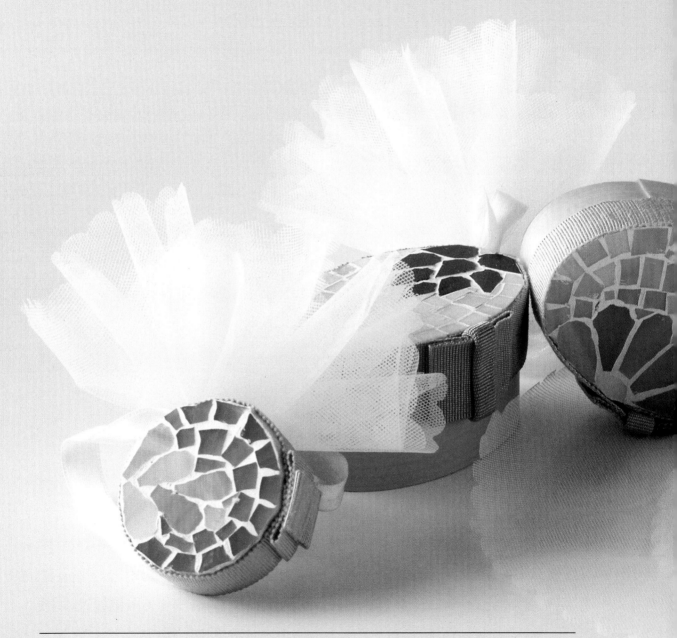

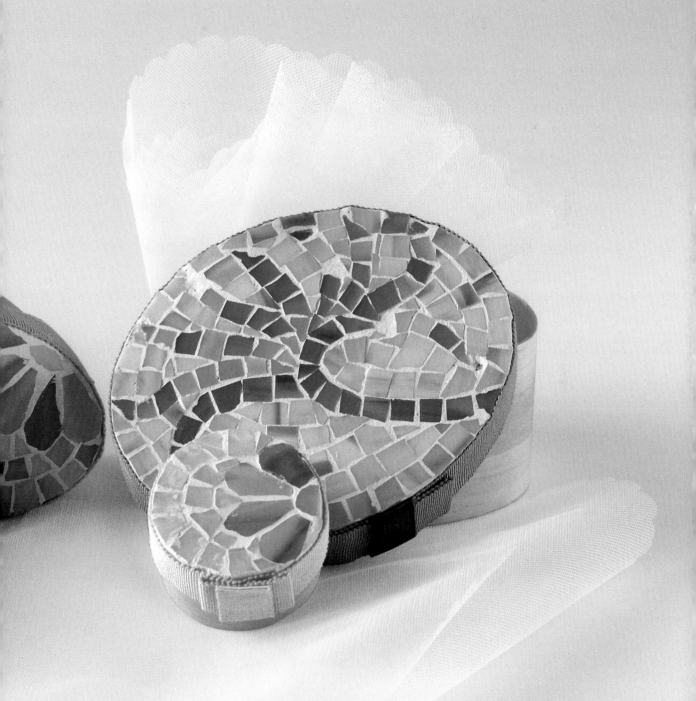

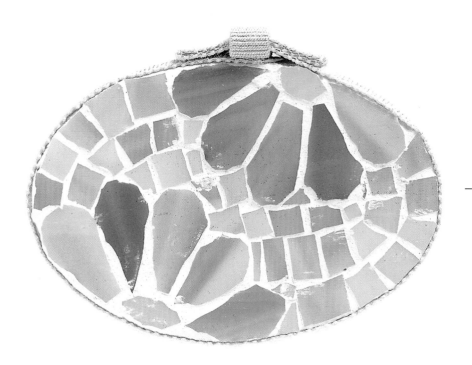

This small oval box features big blue flowers against an aqua background.

This oval box has an aqua design against a cream-colored background.

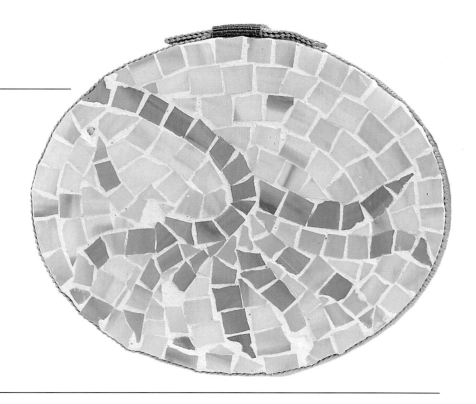

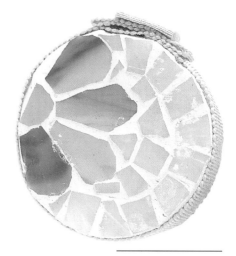

A few opaque green leaves, a yellow transparent glass background, and some colored cement make this little box charmingly unique.

Here is a big, colorful daisy surrounded by an icy blue-white background.

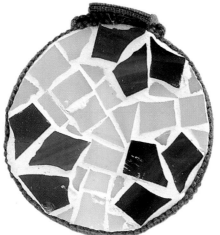

This box features an abstract design in shades of blue.

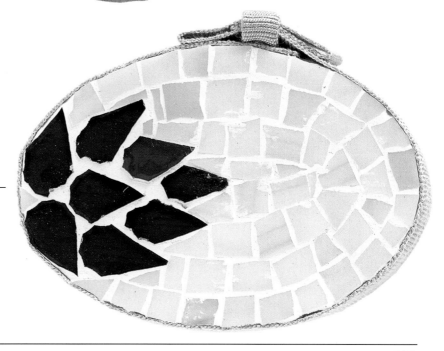

The warm pink background on this oval box provides a sharp contrast to the deep purple petal design.

These box lids were decorated with random glass bits. Their specialness comes from the oval glass beads that were added.

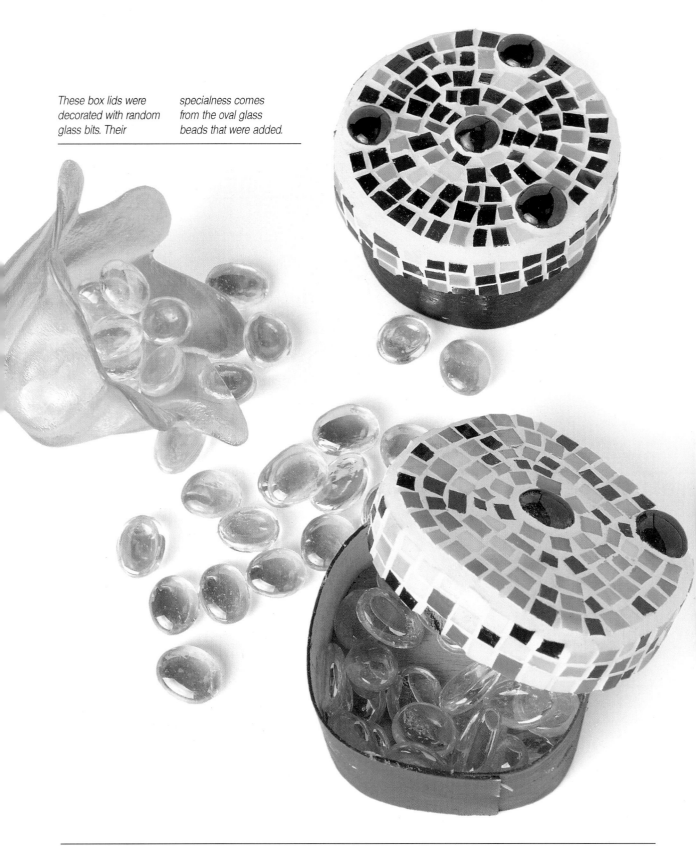

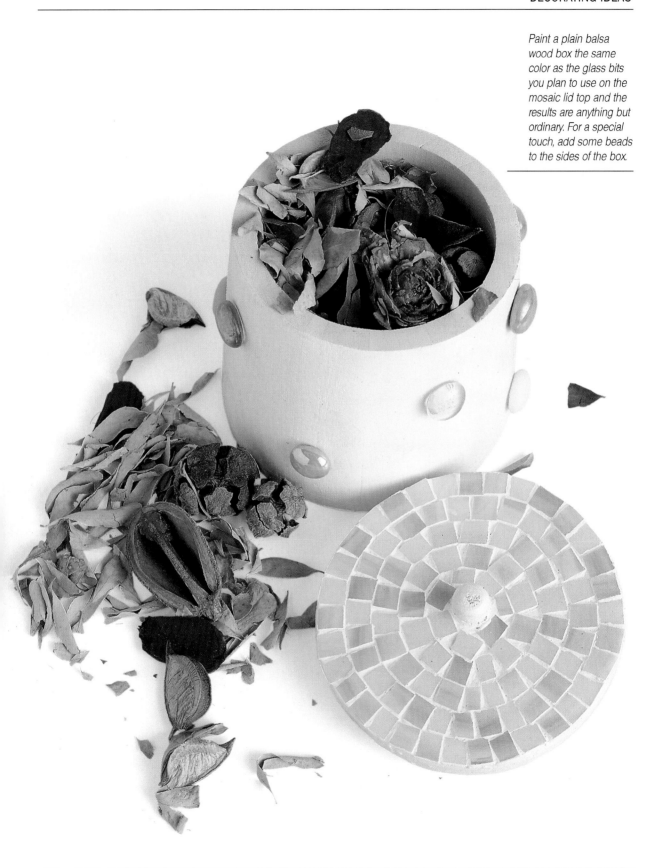

Paint a plain balsa wood box the same color as the glass bits you plan to use on the mosaic lid top and the results are anything but ordinary. For a special touch, add some beads to the sides of the box.

JEWELRY

Mosaic jewelry has an old and honored tradition. During the nineteenth century it was popular to wear mosaic medallions and brooches made from very tiny bits of glass. They were truly unique works of art, but over time mosaic jewelry has become mass marketed. The pieces here were done by Chiara Di Pinto, and they are very suggestive of yesteryear.

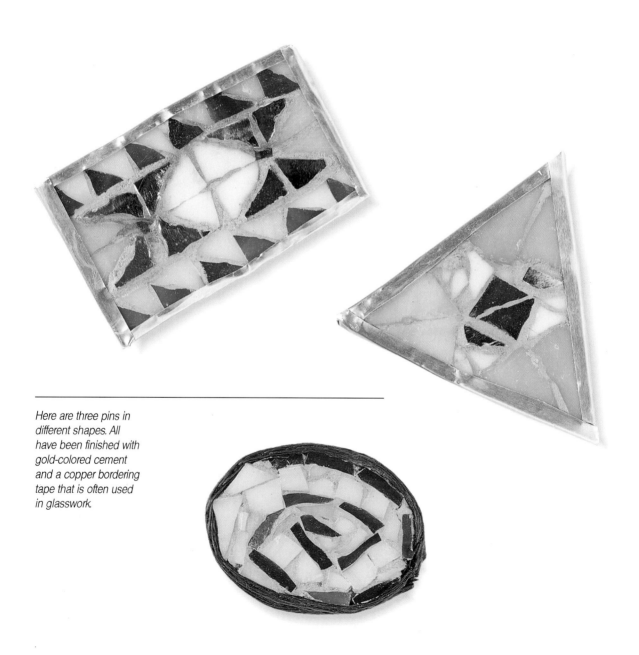

Here are three pins in different shapes. All have been finished with gold-colored cement and a copper bordering tape that is often used in glasswork.

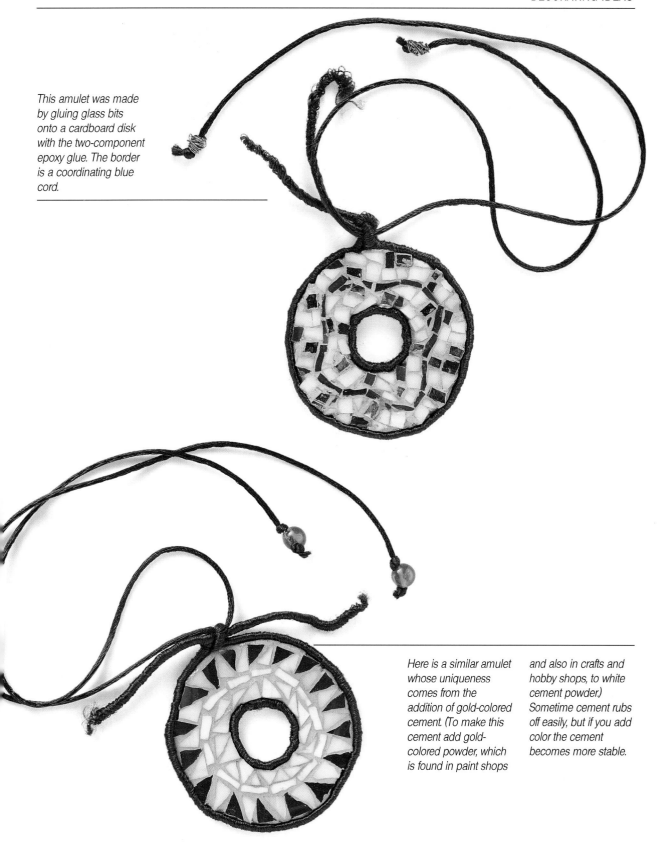

This amulet was made by gluing glass bits onto a cardboard disk with the two-component epoxy glue. The border is a coordinating blue cord.

Here is a similar amulet whose uniqueness comes from the addition of gold-colored cement. (To make this cement add gold-colored powder, which is found in paint shops and also in crafts and hobby shops, to white cement powder.) Sometime cement rubs off easily, but if you add color the cement becomes more stable.

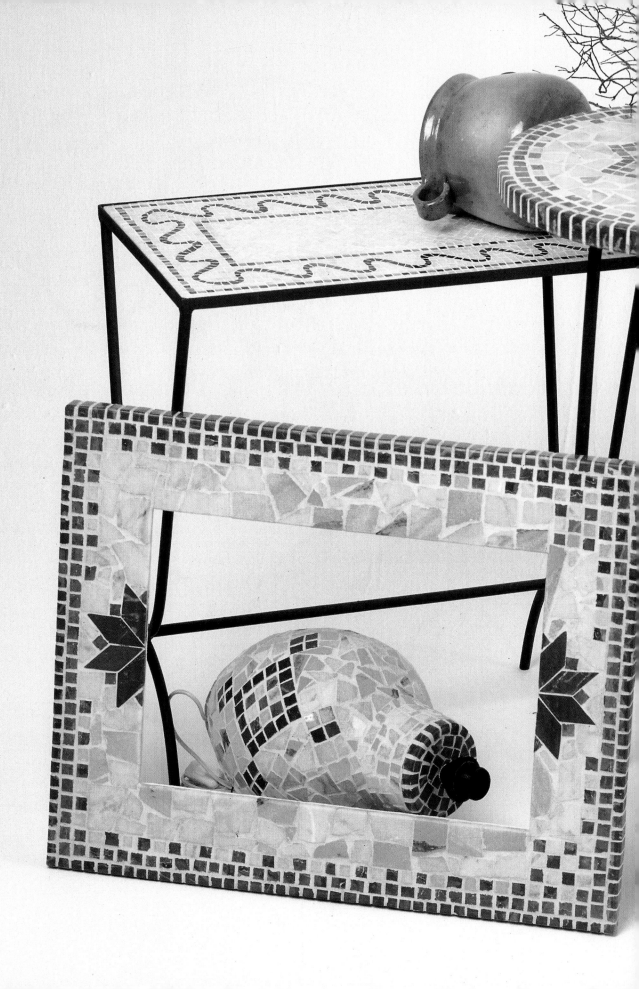

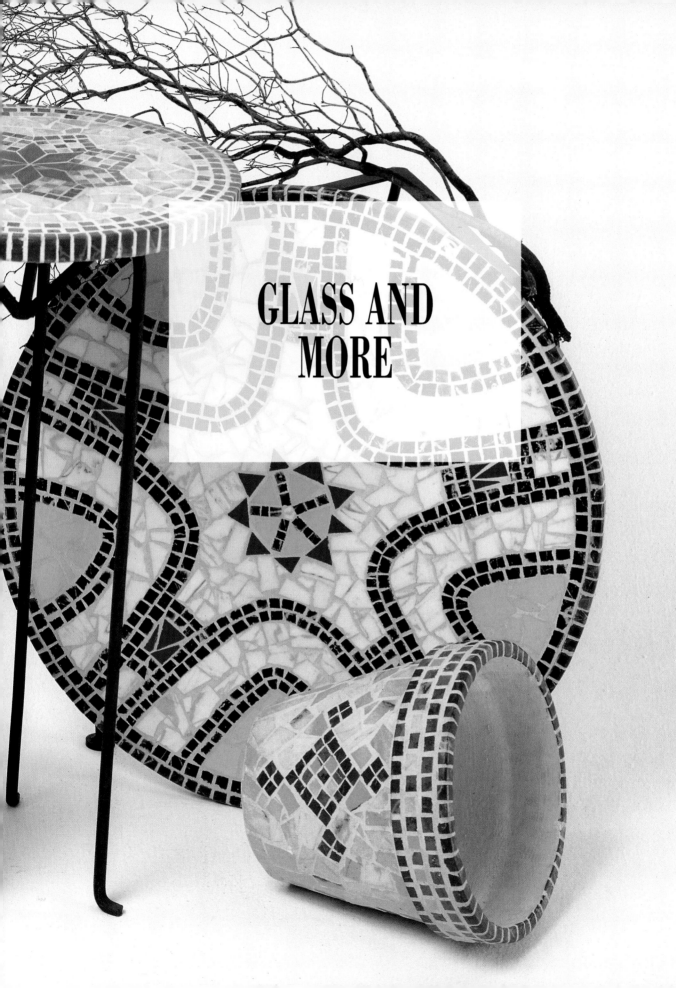

GLASS AND MORE

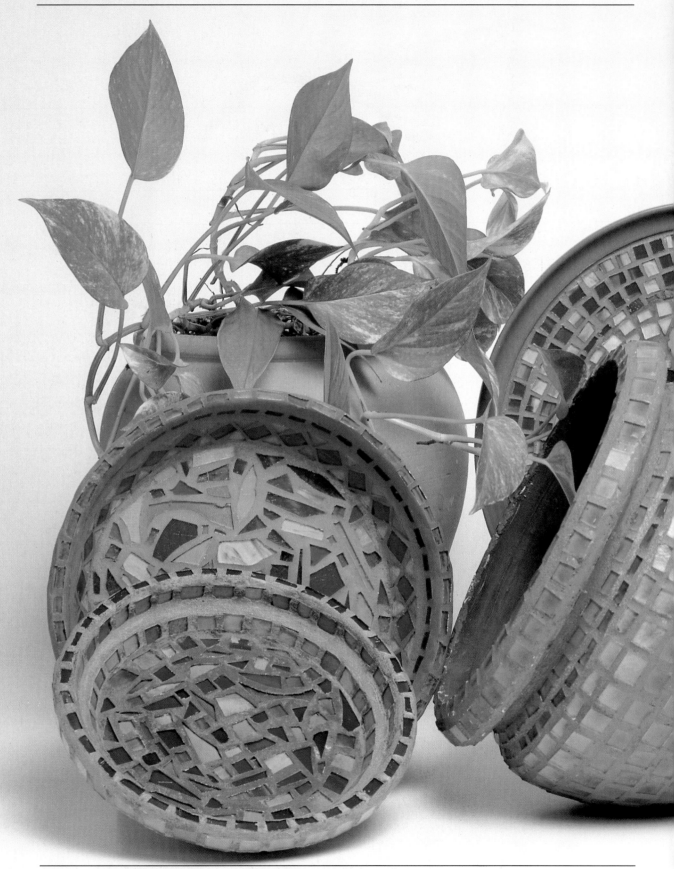

TRANSPARENT GLASS

Here is a group of particularly luminous mosaic items. The Tuscan craftsman who decorated them (and who also made the terra-cotta vases) used colored transparent glass, the kind used for artistic glasswork. Using these bright colors creates very lively and eye-catching designs.

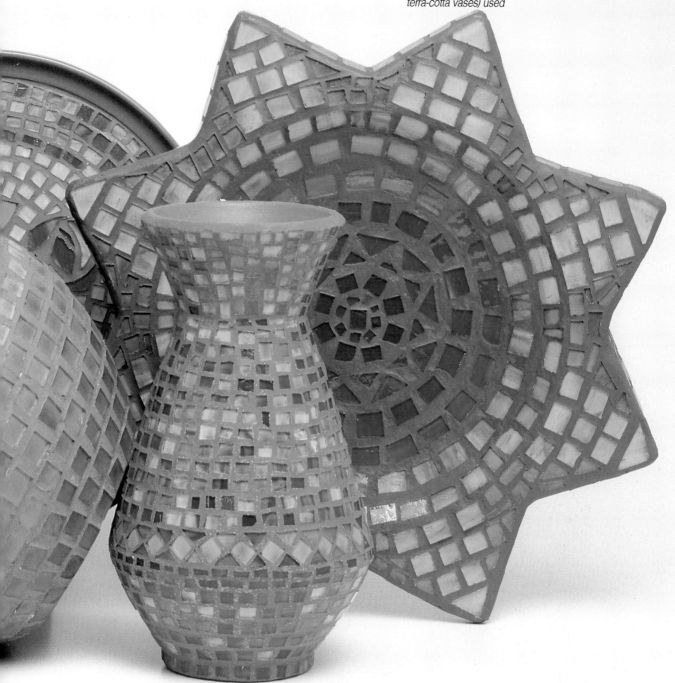

This terra-cotta plate is covered with brightly colored transparent glass and accented with green cement.

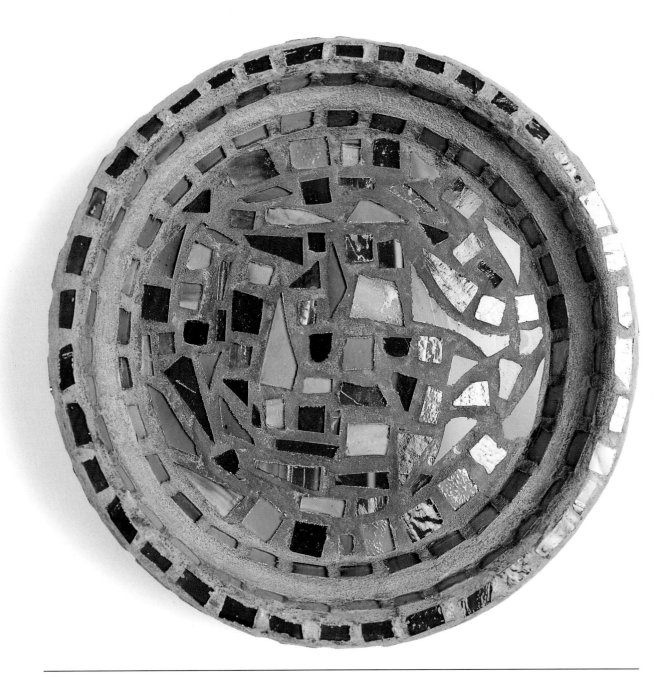

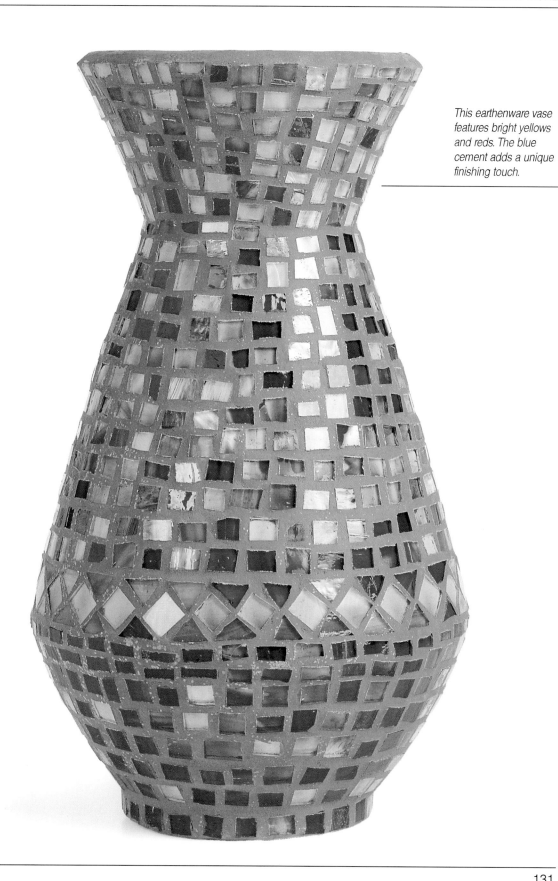

This earthenware vase features bright yellows and reds. The blue cement adds a unique finishing touch.

This flowerpot is covered with hues of transparent blue glass and finished with a blue cement.

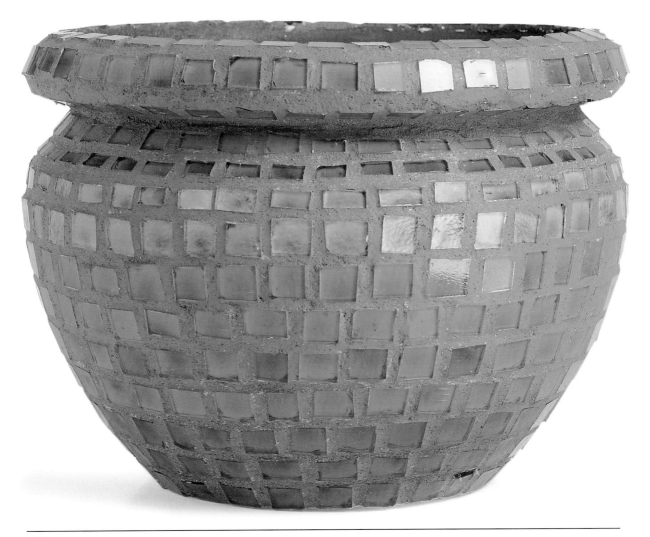

This round plate is unusual because it features two different brightly colored cements.

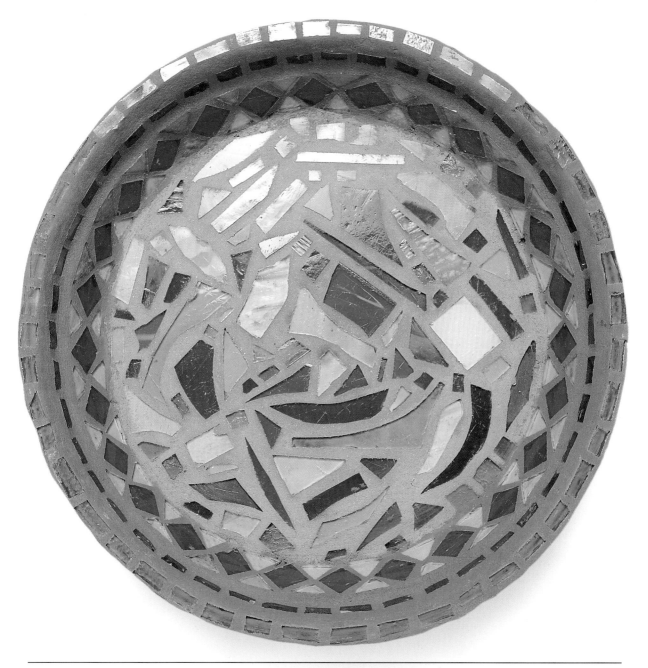

This star-shaped plate has darker shades in the center and lighter ones toward the outer edge.

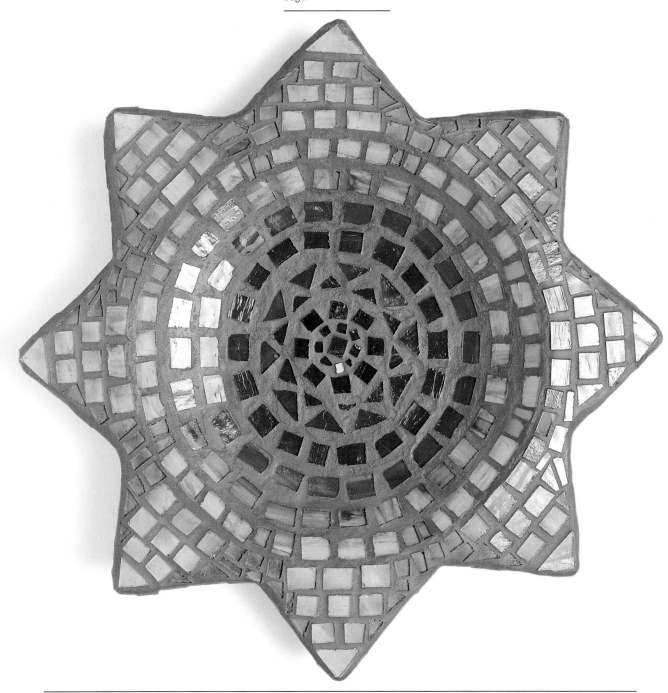

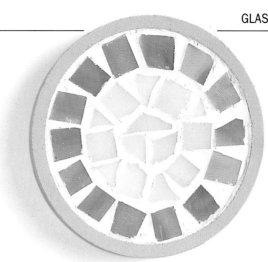

Coasters are quick and easy to decorate, and they make a fun beginner's project. You can find plastic or glass coasters in crafts and hobby shops.

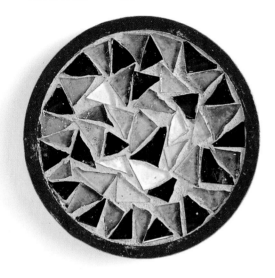

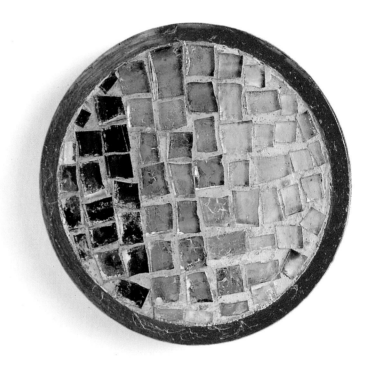

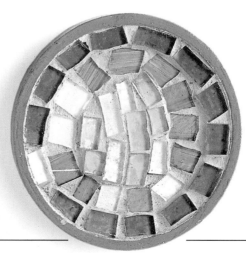

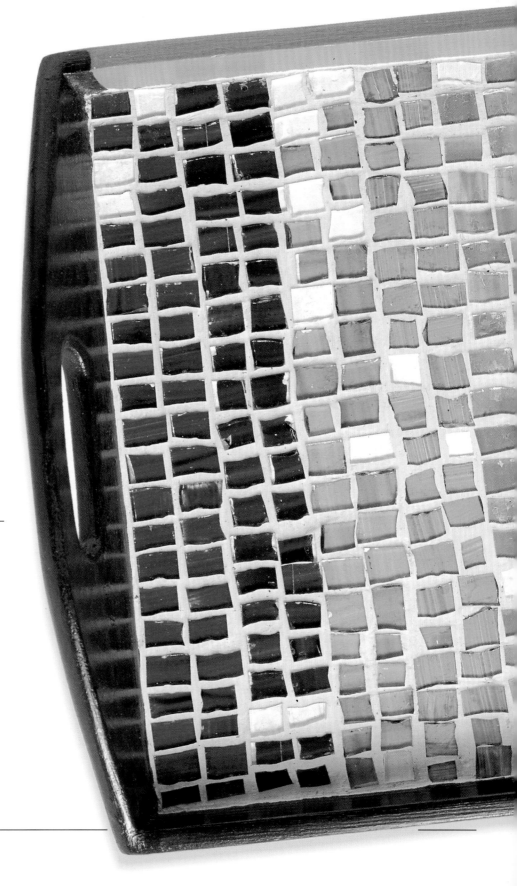

The design of this tray has an intentionally uneven feel. The painted clear-glass bits were glued with the painted side down. The cement was colored yellow, and the bare wood sides were painted partially black and partially green.

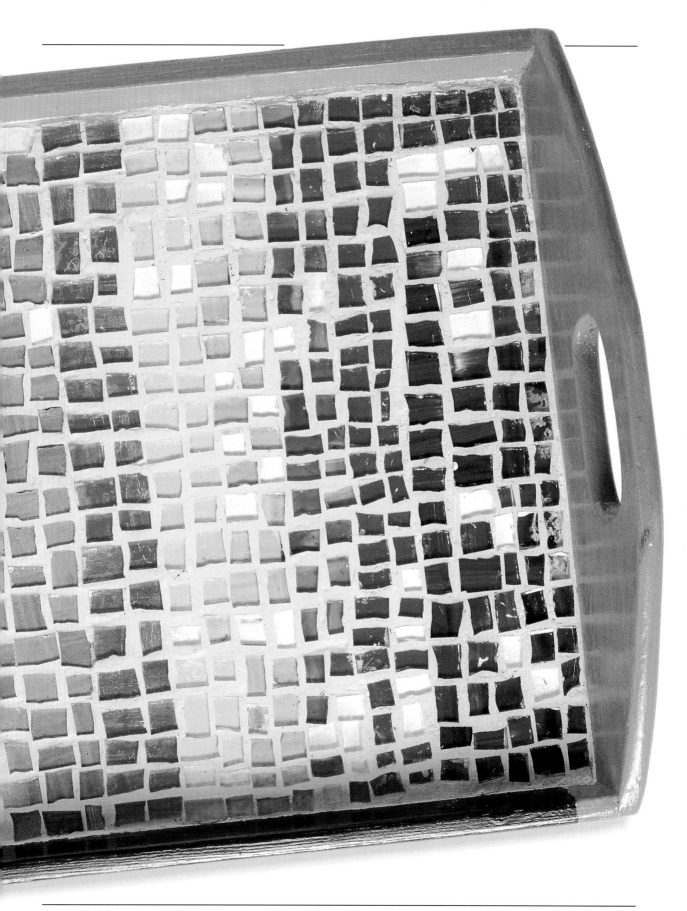

MARBLE

Here is an example of the furniture design collaboration between two young artists, Elisabetta Grossi and Henk Fokkema, and an experienced craftsman. Using the marble mosaic technique of inserting the mosaic bits directly into the cement already spread

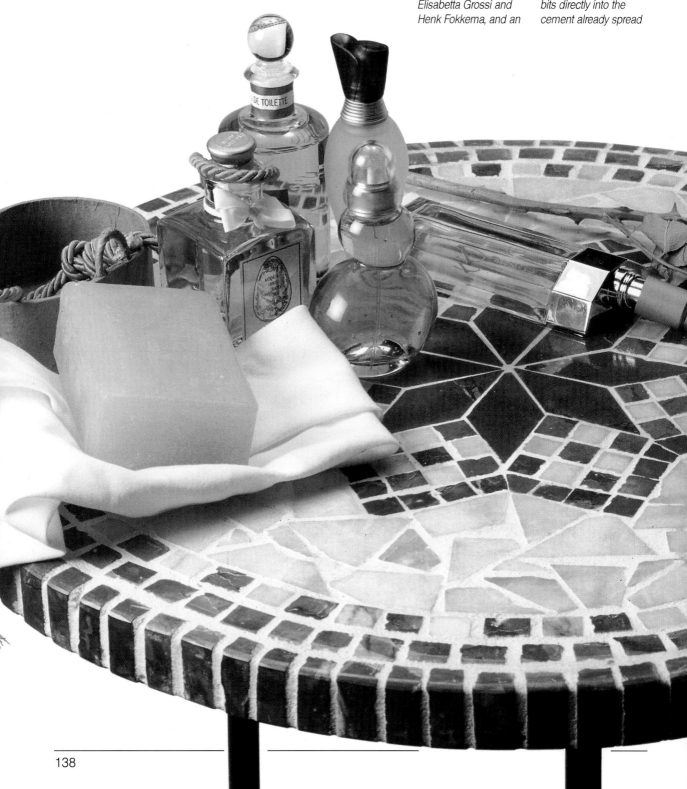

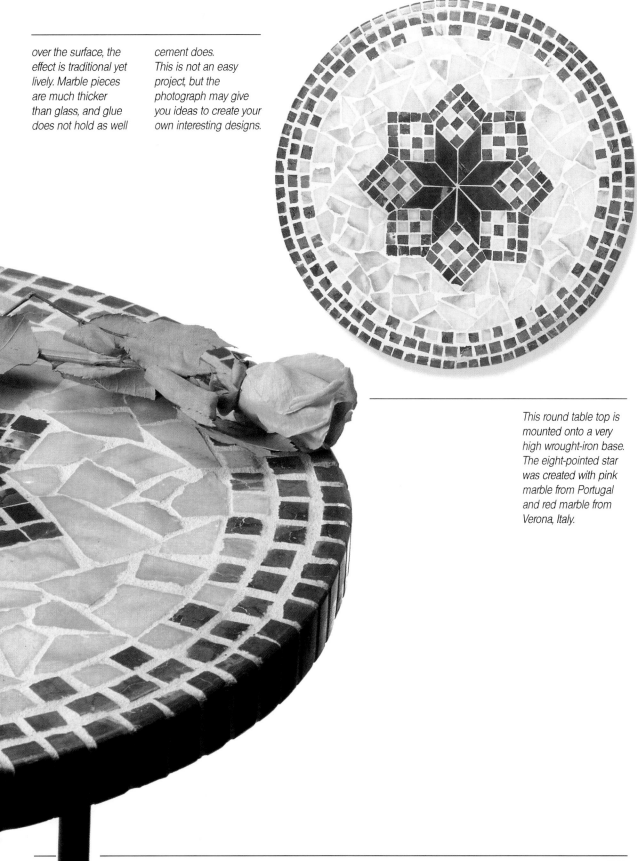

over the surface, the effect is traditional yet lively. Marble pieces are much thicker than glass, and glue does not hold as well cement does. This is not an easy project, but the photograph may give you ideas to create your own interesting designs.

This round table top is mounted onto a very high wrought-iron base. The eight-pointed star was created with pink marble from Portugal and red marble from Verona, Italy.

This lamp base was made from a terra-cotta jar. It was first covered with cement and then decorated with pink and red pieces of marble.

The same pink and red marbles were used to decorate this large picture frame.

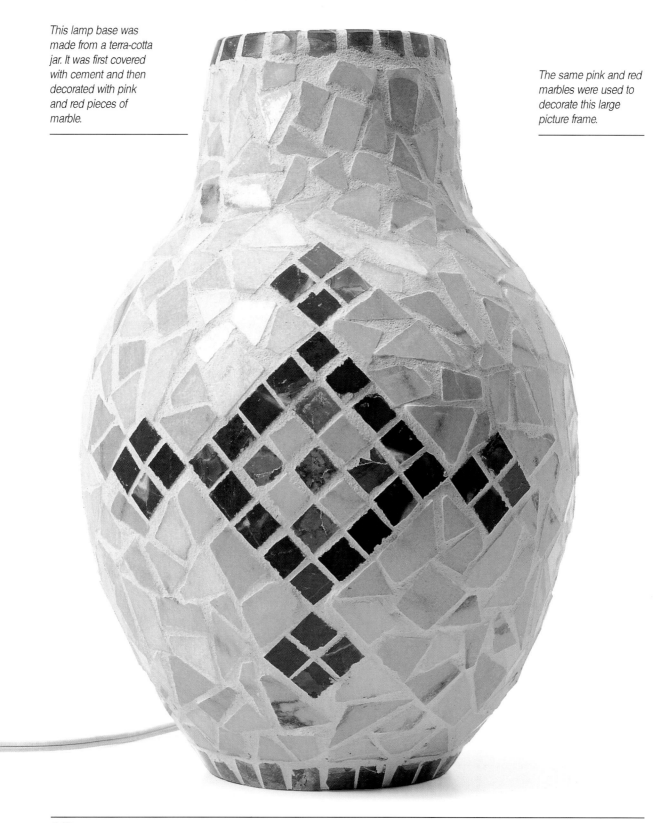

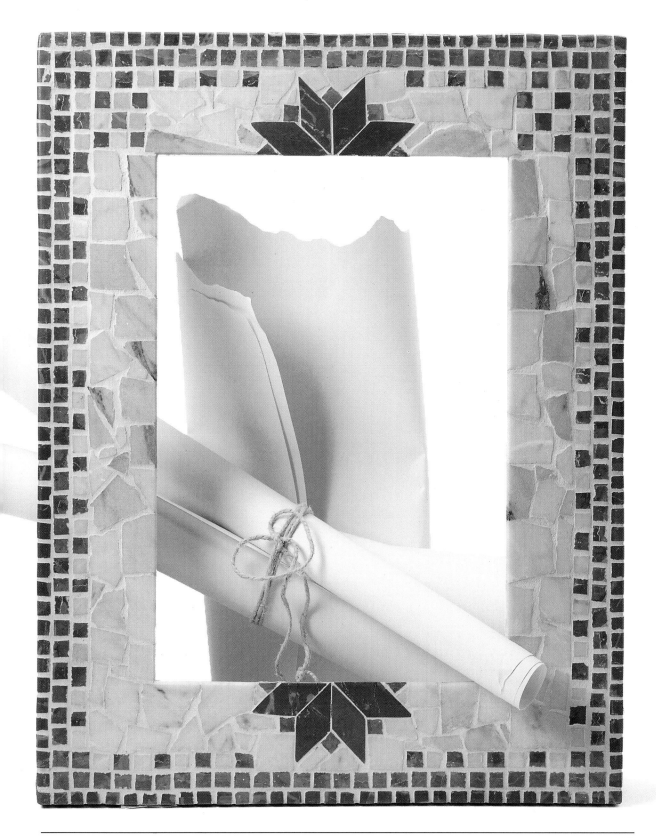

FROM CRAFT TO ART

Here is the work of a craftswoman who moves in the medium of glass the way a dancer moves on a stage. The work of Donatella Zaccaria is lively yet somehow comforting. She works with second-hand furniture to change its look as well as its function. Her pieces attest to the versatility of mosaic work and the great expressive potential of this technique.

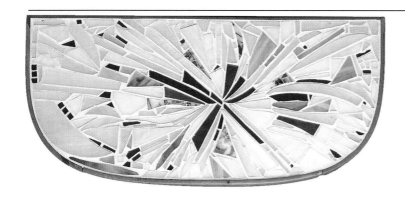

Wall console without legs. The surface is covered in "broken" glass placed in the center and fanning outwards.

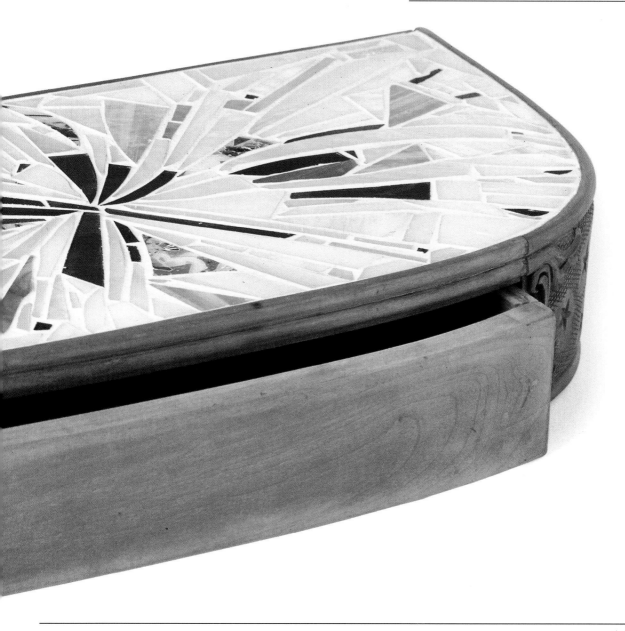

An old wood bookcase becomes transformed when top and bottom are decorated with red, black, and white pieces of glass.

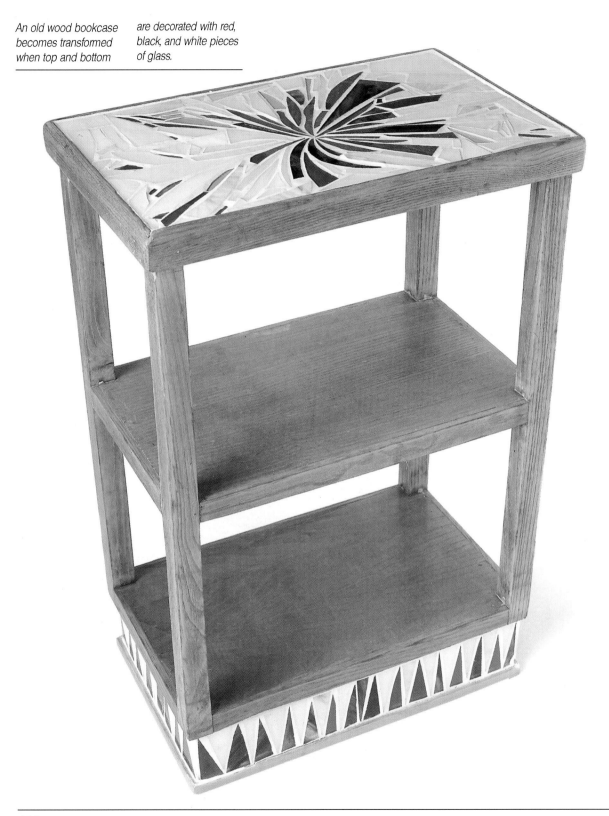

This small shelf becomes a work of art when it is covered with glass triangles in various contrasting colors.

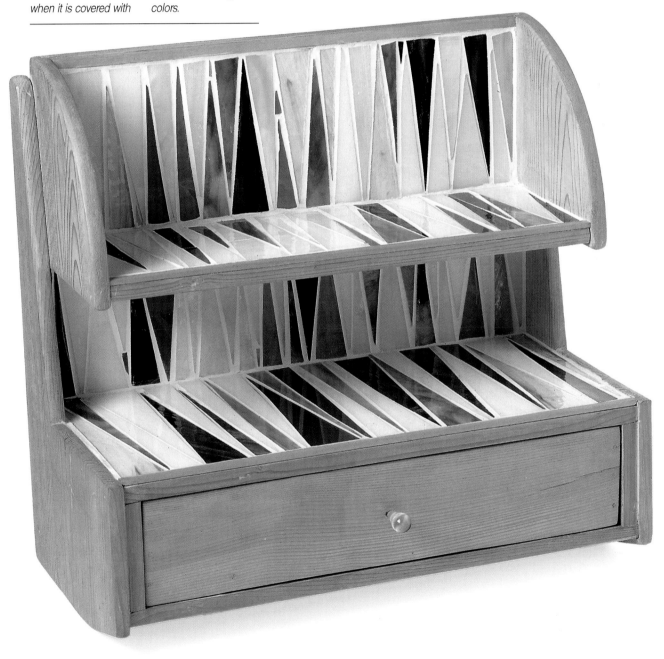

PATTERNS

These are patterns that you can use in your own projects or as inspiration for your originality. Trace or photocopy the patterns, enlarging or reducing them in size as necessary for each of your projects.

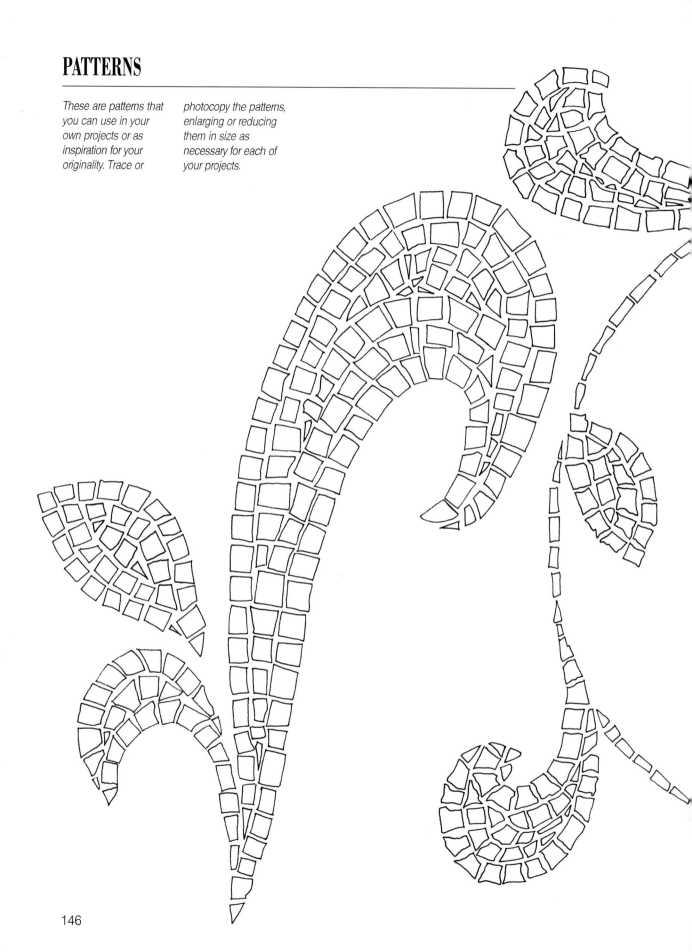

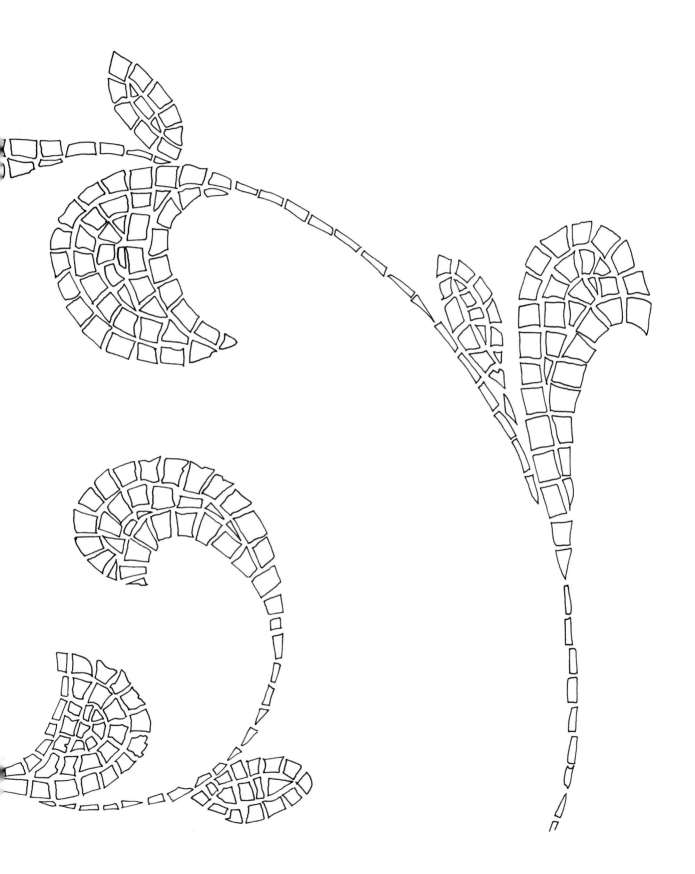

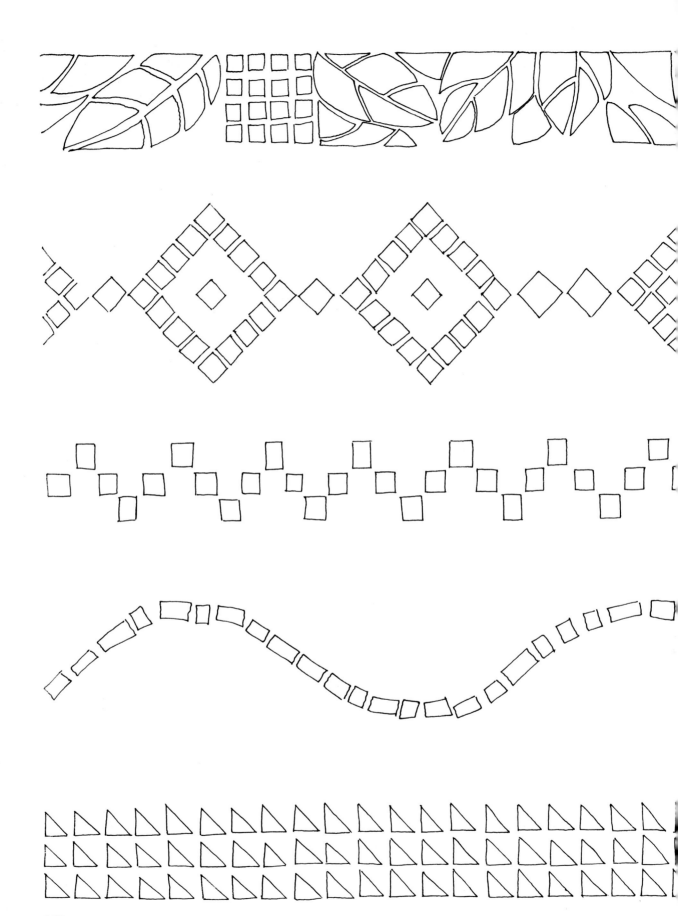

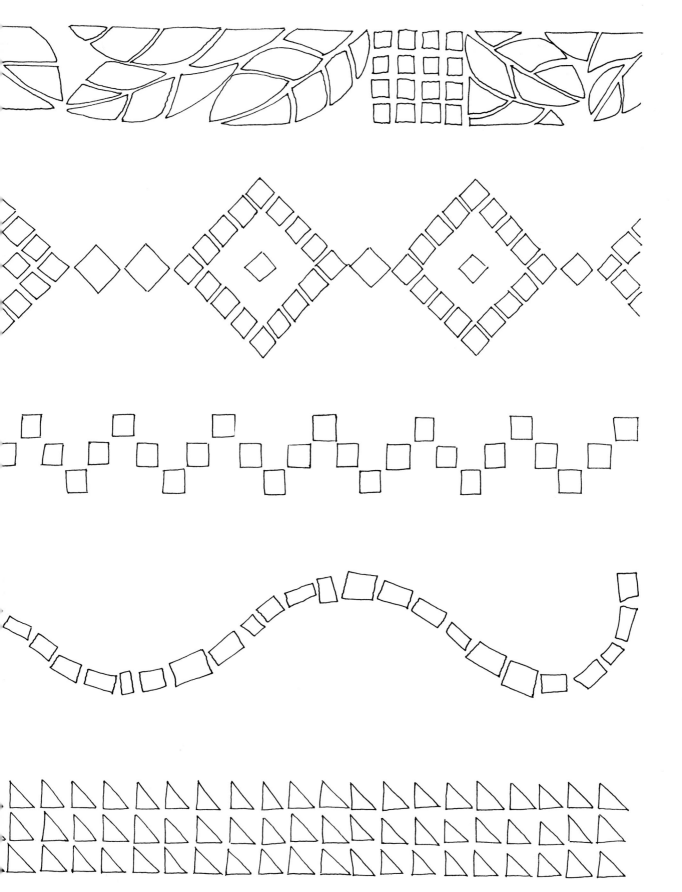

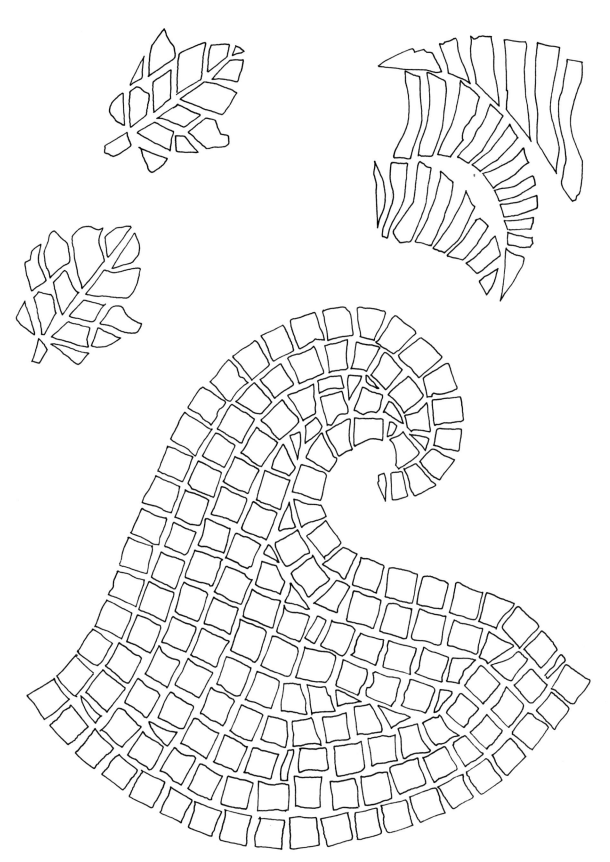

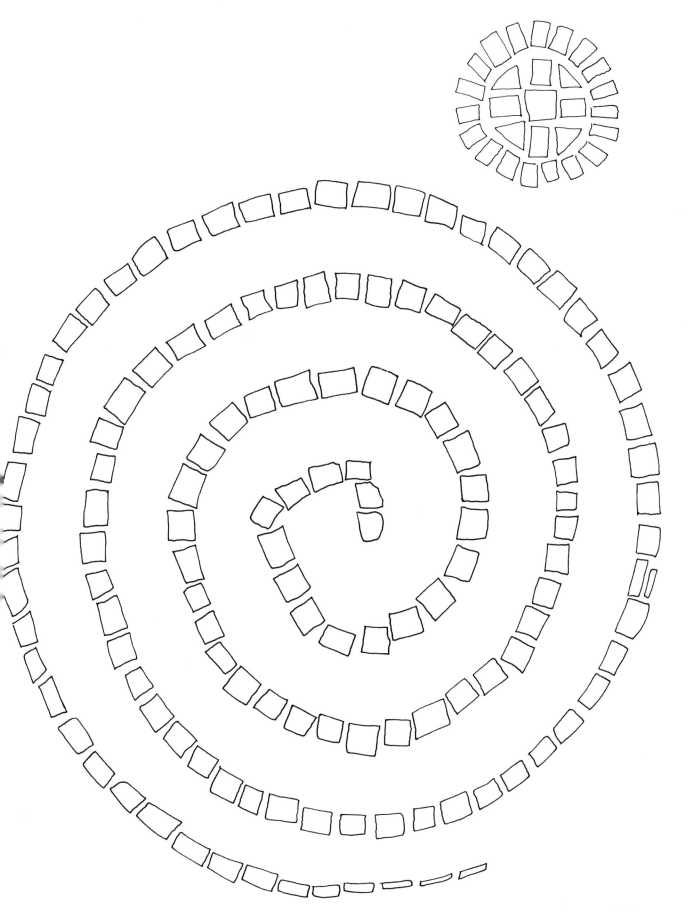

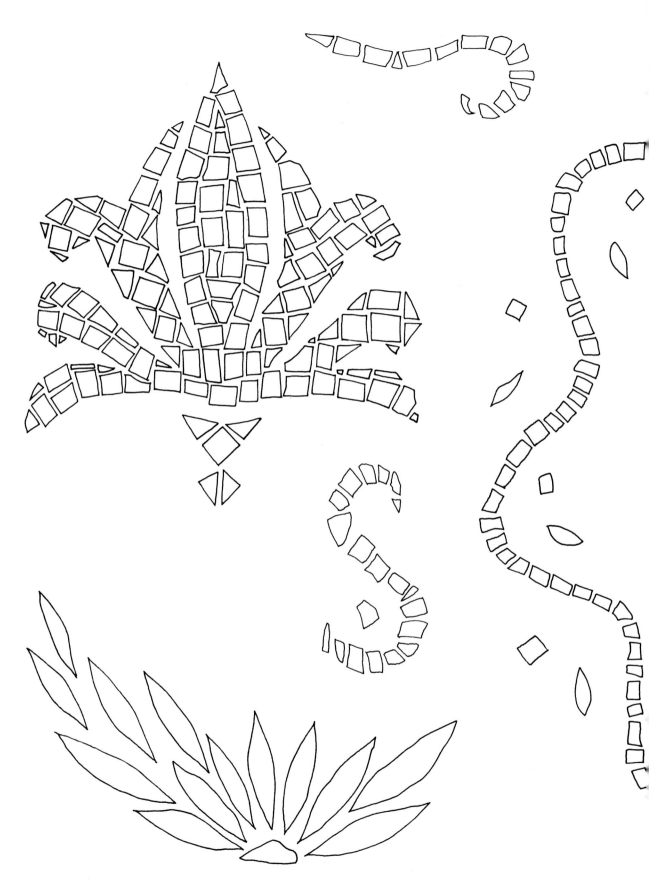

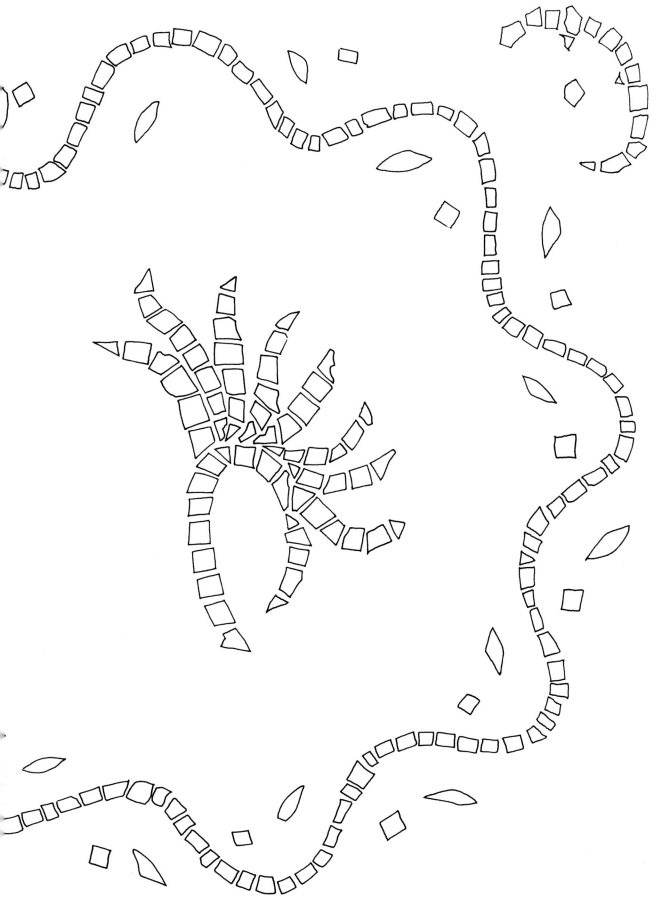

154

Photographs by Alberto Bertoldi

Graphics and paging: Paola Masera and Amelia Verga

Translation: Sally Bloomfield

Typeset by G&G computer graphic s.n.c.